AUSTRALIAN Naive ART

AUSTRALIAN

Naïve

ART

Sandra Warner

CRAFTSMAN HOUSE

Distributed in Australia by Craftsman House,
20 Barcoo Street, Roseville East, NSW 2069
in association with G+B Arts International:
Australia, Austria, Belgium, China, France, Germany,
Hong Kong, India, Japan, Malaysia, Netherlands,
Russia, Singapore, Switzerland, United Kingdom,
United States of America

ISBN 976 8097 53 1

Design *Ingrid Carlstrom*
Printer *Tien Wah Press Pte. Ltd, Singapore*

Contents

to

Betty and Rex

Acknowledgments

I would like to thank all the artists who participated in this book for their support and co-operation, the collectors who lent their works for reproduction and Robert Walker for his photographs and excellent company. I would also like to acknowledge the following individuals and organisations for assisting with information and photographs: Vivienne Binns and Wayne Hutchins; Frank Watters; Dr Ernest Smith; Etienne Cohen; Rachel Wake; Australian Naive Galleries (now defunct); Tandanya National Aboriginal Cultural Institute; Museum of South Australia; John Wilson, Nursing Archive of Australia; Riverhouse Galleries, Brisbane; Etienne Roy; Riddoch Art Gallery, Mt Gambier; Andrew Eastick, South East Cultural Trust; Pat and Richard Larter; David Lever; Malcolm Otton; David Mahony; Peter James; Ray Hughes Gallery; Dr Joe Airo-Farulla; Marilyn Domenech, Baguette Gallery, Brisbane; Dr Basil Bierman; Devonport Gallery & Arts Centre; Annie Franklin; John Firth-Smith; David Isbister; Stephen Rainbird and Tracey Muche, University Art Collection, Queensland University of Technology; Gregory Ford Antiques; Lord McAlpine of Westgreen and Joan Bowers. Jacqueline Jensen helped enormously by compiling the biographical material. Special thanks to my dear friend Mark Robertson for the long loan of his word processor.

Introduction

In the course of researching this book, I went to a small country town to interview a retired plumber, Mr Geoffrey Rayner, who at sixty-eight can still form up a water tank with the best in the district. Mr Rayner is passionate about plumbing — its history, its materials, its equipment. He recycles corrugated iron into eccentric storage and waste bins, mailboxes, bird-houses and spotted duck weather-vanes. In order to preserve and display his vast collection of plumbing and bush tools, old farming implements and vintage taps, he has constructed self-contained, portable 'museums' which he labels and decorates with tin cut-out stars, hens, ducks and sunflowers.

Inside Mr Rayner's 'studio', a tin shed he refers to as his 'Iron Lung', I admired what I assumed to be a decorative finish on the corrugated surface of one of his works. Shaking with mirth, he revealed that this 'interesting texture' on the sheet of iron was the result of a mishap during production and that the offending piece of metal had been discarded by the manufacturer. Where the plumber saw a tankmaker's blunder, I saw artistic success.

Mr Rayner's intention is documentary rather than artistic. He measures the success of his inventions by their utility and economy and their capacity to house treasured superseded taps, rabbit traps, fencing equipment and well-worked axes and adzes. He was astounded when the Museum of Contemporary Art in Brisbane bought three of his 'museums' for their collection and still believes that they belong in a social history museum. Mr Rayner did not set out to become an artist. That his constructions are seen as art works is, I suspect, a constant source of amusement for him.

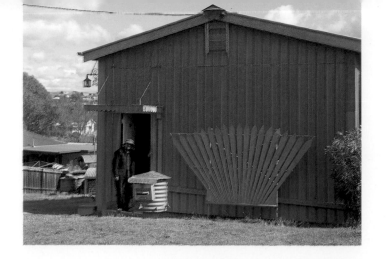

Above
GEOFFREY RAYNER
Outside The Iron Lung, *1993*
Photograph: Robert Walker

The 'museums' strongly suggest the shape of a dunny, a form of vernacular architecture ubiquitous in rural Australia. A curved wall of gleaming new corrugated iron holds a collection of timber samples and old woodcutting tools. Another smaller piece of pink-rusted iron lies across the top, sheltering the display. Corrugated iron is synonymous with the Australian bush. It is redolent of the heat and glare of the summer, blowflies, the sound of the rain whipping the house in a storm. As a material, it is the perfect backdrop for Mr Rayner's museum pieces, complementing the graceful arcs of tool handles and the bush tones of timber specimens. To Mr Rayner, decorative devices are tacked on as afterthoughts, but his roughly-hewn cut-out ducks jeer at the mass-produced plague of weathervanes while reminding us of another emblem of country life.

It is the intention of its exponents that most distinguishes naive art from other art forms. Mr Rayner makes plumbing museums. Miriam Naughton tried painting as a way to capture her memories. Sister Clare Connelly thought she was 'hopeless' at art until a highly regarded painter, Bill Robinson, told her that her first picture was 'true naive'. Lotje Meyer couldn't afford original paintings to decorate her house, so she began making them herself. John Venerosa 'fell into it'. Bob Marchant had intended to write, not paint.

Naifs paint primarily for themselves. The work of other artists is irrelevant. Art history is irrelevant. Contemporary practice is ignored. While all artists like their work to be appreciated, the naif sees this as a bonus rather than a goal. They don't set out to gain critical acclaim and often don't take up painting until their retirement, or they do it because they've always done it and to not do it is unthinkable.

Naifs are often colourful characters who came to painting late in life. Australian naif Sam Byrne worked in the Broken Hill mines from the age of fifteen until his retirement in 1949. He had been the best in the drawing class at school so that when he finally had the leisure, it occurred to him to take up sketching. Byrne started painting when he was about seventy, embarking on a long series of pictures which chronicle the social history of Broken Hill.

Artistic success came as a complete surprise. Invited to put some paintings into a local exhibition he agreed, thinking it would be nice to see them up on a wall. Byrne was astounded when they were given prizes and people wanted to buy them. His paintings are now included in national collections.

Byrne's rabbit plague pictures are vivid records of one of the most sensational phenomena in Australian rural history. Broken Hill survived several rabbit plagues during Byrne's lifetime. In a good season this introduced species would reproduce so industriously that a drought would

SAM BYRNE (1883–1978)
Rabbit Plague, n.d.
Oil on board, 38 x 68 cm
Collection: Etienne Cohen
Photograph: Robert Walker

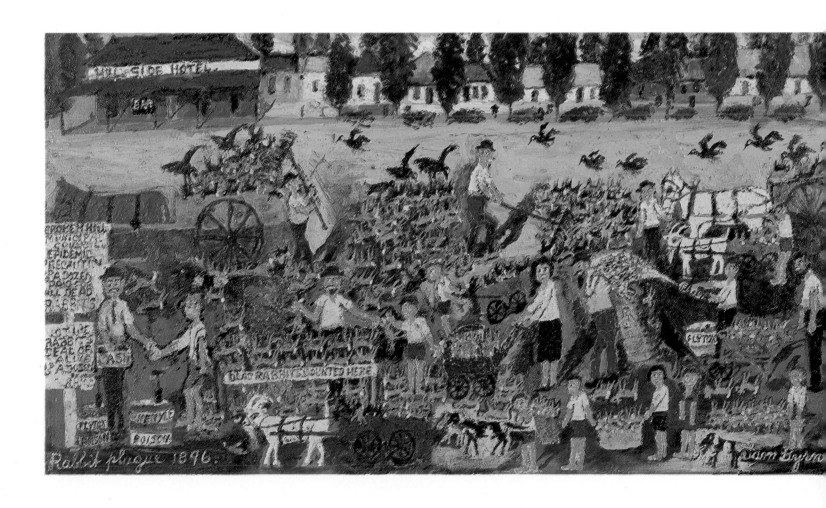

force hordes of them to come off the arid land into town, desperate for food and water. The streets would be literally covered in dead and dying rabbits. During one such plague, Broken Hill Council, concerned about typhoid fever, announced a bounty of sixpence a dozen on dead rabbits. Broken Hill was completely devoid of rabbits within a week.

Henri Bastin ran a camel mail service in the outback, mined opals in Queensland and gold in Western Australia. At the age of fifty, looking for something to do on a cattle station on a rainy day, he painted his first picture using a brush fashioned out of horse hair and sheep-brand colours on whitewashed newspaper. This crude beginning heralded an output of over one thousand paintings in a period of ten years.

Malcolm Otton, now a 'naive' painter himself, chanced upon Henry Bastin's work while researching a film on life in Perth for the Commonwealth Film Unit in the 1950s: 'I was at the Art Gallery of Western Australia digging through a plan cabinet looking for historic maps and drawings of the Swan River and the early settlement. The Curator, Bill Brown, who was guiding me in this, pulled out a whole swag of paintings on paper.

'When I asked who the artist was, he replied, "A wonderful mad old Belgian guy who lives up at Meekatharra, a mining town way up north of Perth. He lives off the land. He has a bicycle, a rifle, and he takes a bag of flour, some bullets, and he shoots rabbits and goannas. And he paints. When he wants some actual money, he goes into Meekatharra to work on the gold mine." Brown said that Bastin was interested in selling his work to make money, and he thought I might be able to help by taking a bundle of paintings back to Sydney and trying to sell a few.

'I agreed and when I got back to Sydney I borrowed the boss's office and spread the pictures out over his big desk. I'd told various people, mainly friends, who I thought might be interested and sold about ten of them for something like five pounds each'. A friend at that time, Lillias Fraser, helped by taking some pictures to sell to her colleagues, using the unusual venue of the ladies powder room. The Bastin painting shown here is the picture she bought for herself at the time.

'I took the ones I didn't sell back to Perth on my next trip. When I gave them to him he told me that Henri was in town and did I want to meet him? I said I'd love to meet him as I'd kept two or three of his pictures for myself. I drove out to the suburbs to a grotty old place: a little tin-roofed cottage, like Paddington in its run-down days. Pretty grim. I knocked on the door and out came an enormous great barrel of a man with grey bristly hair and a big red face who said, "Vat d'you vant?" I told him that I had sold some of his paintings and he literally came at me shouting, "Vere's the money? I vant the money!". I thought he was going to beat me up! I couldn't make myself understood, so I beat a rapid retreat.

HENRI BASTIN (1890–1980)
Landscape, 1960
Gouache on paper, 49.5 x 60 cm
Collection: Lillias Fraser
Photograph: Robert Walker

'When I got back to the Gallery, Bill Brown roared with laughter and finally said "Well, I can tell you what that was all about. I helped Henry send some paintings to a Melbourne gallery and they'd sold some but hadn't sent the money yet." I never met him again, but I followed his career with great interest.'

Malcolm Otton, again through his work with the Commonwealth Film Unit (now Film Australia), met another naif, Selby Warren.

'I'd got the "Australian Eye" series on Australian painters under way when one day I had a ring from Garth Dixon, an art teacher at Bathurst CAE who told me that he had discovered a marvellous naive painter who was going on for 80 years old. His name was Selby Warren. He lived way out in the bush and had never had an exhibition, but his cottage was full of paintings. He made the frames out of branches of trees and soapboxes. Garth told me that he was a real "primitive" and thought he'd make a great film because he was such a picturesque kind of character.

SELBY WARREN (b.1887)
Sydney Harbour Bridge, n.d.
Housepaints on corrugated
cardboard, 50 x 70 cm
Collection: Ray Hughes Gallery
Photograph: Robert Walker

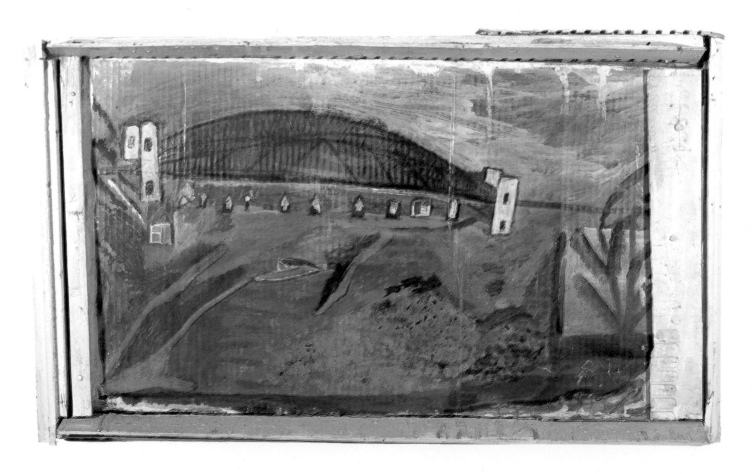

Above
CHARLES CALLINS, c.1965,
Photograph: Robert Walker

'One weekend a few of us drove up to where he lived at Trunky's Creek, Garth having warned the old boy that we were coming. We arrived at a tiny cottage, and had a very nice afternoon tea. I remember vividly: his wife had very rosy cheeks and she'd baked some scones for us.

'Afterwards, Selby started pulling out pictures from behind the wardrobe, from on top of the cupboard, from under the bed — he had pictures everywhere. Some of them were really beautiful, quite smashingly wonderful, true naive paintings. He told us about fossicking for gold in the Abercrombie River, then pulled out a painting of swans. Along the bottom of the painting was the picture's title: "Swans on the Abercrombie River" in large lettering. The frame was made of pieces of old boxwood painted black, with tintacks nailing the picture to it. You could cut yourself if you put your hand around the back of the picture.

'To cut a long story short, he was quite delightful and we got on very well. I couldn't convince Daniel Thomas, who was consultant on the "Australian Eye" series, to include Selby Warren at that stage. However, Garth Dixon and Rudy Komon organised a show of about eighty paintings.

'A bus load of Selby's mates and neighbours came down to Sydney all dressed in their Sunday suits and it was a riot! Everyone was thoroughly plastered by the end of the evening. He sold quite a lot of pictures, but I think that was the only show he had — I never heard of another one — but he started at the top. He was a dear old bloke — very warm and chatty and thrilled to have people taking an interest in his work, but he did it because he liked it — like all naives do I guess.'

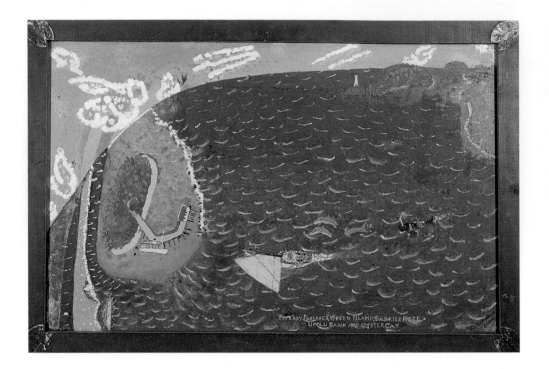
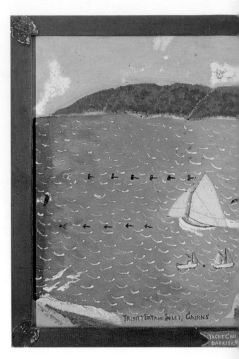

CHARLES CALLINS (b.1887)
Yacht Cruise to Green Island, 1966
Oil on board
Three panels, each 57 x 88 cm
Collection: John Firth-Smith
Photograph: Robert Walker

Charles Callins seems to have become an artist almost by accident — some years after his retirement in 1947 from a career in newspaper production. One day in Cairns, where Callins spent most of his life, a woman school teacher was rescued after falling from a ferry. Callins thought he'd try illustrating his written account of the event with a picture and was so pleased with the result he continued to paint. However, for Callins, a natural archivist, the paintings were only ever intended to serve as illustrations for his written records. In his desire to be accurate, Callins distorted perspective in order to show what lay around the corner of a headland or behind an island.

Contemporary Australian painter John Firth-Smith collects marine paintings and is particularly enthusiastic about Charles Callins:

'I like primitive painting. I like the innocent quality. Although I don't really know what you call it. Some people call it "naive". I've always had a problem labelling that sort of picture.

'I've had these Callins since 1966. I'd had an exhibition that year at Gallery A and a couple of shows later was a Callins show. I bought those three pictures or swapped them for some of mine — I can't remember — but one thing I do remember is that with those pictures came

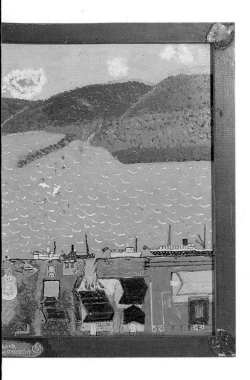
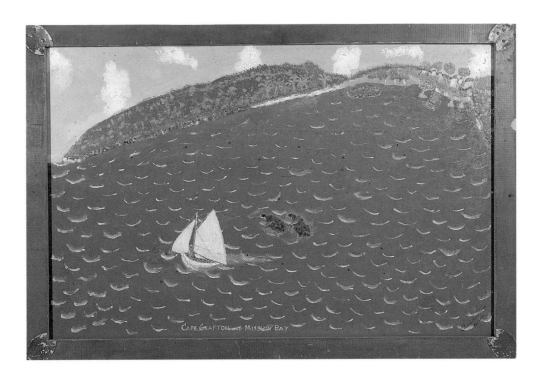

something like twenty foolscap pages of text written by Callins. The pictures were illustrations for

the text which remained in the Gallery A file.

'Callins made the frames himself. They look pretty crude. There are screw holes in them which

suggest that they have been joined. I hang them together — there's a wonderful rhythm that

goes through the three pictures. I think he intended that they be treated as one picture.

They're probably only on separate boards because that was the size of the boards he had

available.

'It was the story of a journey from Cairns to Green Island by yacht. The paintings are early

Charles Callins — they're cruder than a lot of the later works. Later on the pictures became

more lush, more beautiful. I've got some fantastic slides of Charles Callins' paintings which I

sometimes use when I give lectures. There are similarities between the forms in the pictures and

lots of abstract painting and also Aboriginal art. I like the awkward shapes ... and they have a

strange balance or symmetry about them which I find bizarre and very interesting.'

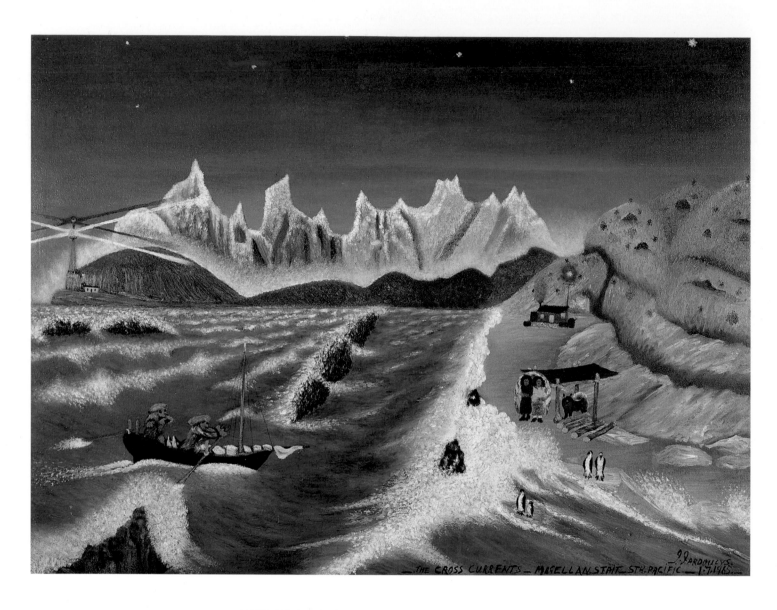

JAMES FARDOULYS (1900–1975)
The Cross Currents — Magellan Strait — South Pacific, *1965*
Oil on canvas, 90 x 120 cm
Private collection
Photograph: Robert Walker

James Fardoulys came to Australia from Greece at the age of 14 and worked in Greek cafes in country New South Wales and Queensland before marrying a ventriloquist. The couple spent many years touring with a carnival show before settling in Brisbane where Fardoulys drove taxis. Like Sam Byrne, he started painting in his retirement because he had been able to draw at school and enjoyed it. Fardouly's subjects were many and varied. He liked painting mountainsides, rocks and always included water in his pictures.

One of the most interesting aspects of naive art is where and how it is found. Although art museums usually hold small collections of naive work and limited numbers of commercial galleries show it, naive art is more often found in the backyards of ordinary suburban homes, in paddocks, under beds, behind wardrobes, in garden sheds and chook pens, in the workshops of retired plumbers, in convents or covering the walls of remote rural dwellings.

The bizarre figures shown overleaf were discovered in the garden of a small Sydney terrace in the mid-1980s by the executors of a deceased estate. While nothing is known about their creator, the figures themselves suggest the forms and ornaments of countries like India, Ethiopia, Etruscan Italy or Northern Africa. Perhaps the painter had worked as a builder — standing almost life-size, they are made of concrete and mounted on simple concrete blocks. Painted with housepaints, the taller sports clay beads and a sculpted crown and the other, a kind of jockey's cap, a bangle and a skirt embellished with a moulded medallion. Their playing-marble eyes lend these garden sentinels an eerie, luminous animation in the night.

In 1987 art staff from the Queensland University of Technology discovered a treasure trove of original artworks in the backyard of a corner shop in the Brisbane suburb of Kelvin Grove. Comprised of over sixty ceramic objects, the collection was acquired and restored by the University and is currently being researched by Dr Joe Airo-Farulla.

The colourful relief pictures describe the unique and highly personal iconography of a man who came to Australia as one of the first of generations of Italian immigrants. Erminio Aili was born in

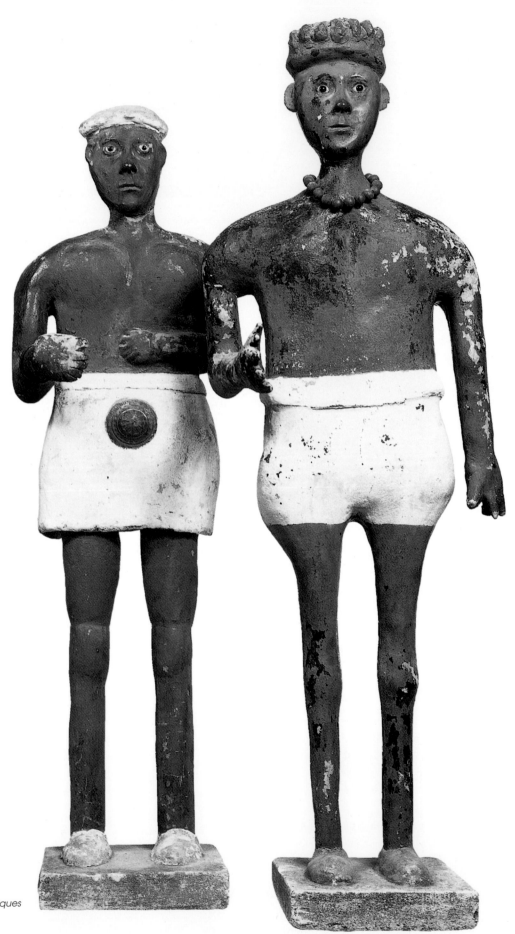

ANON,
Concrete Figures, n.d.
120 x 135 cm
Collection: Lord McAlpine of Westgreen
Photograph: Courtesy Gregory Ford Antiques

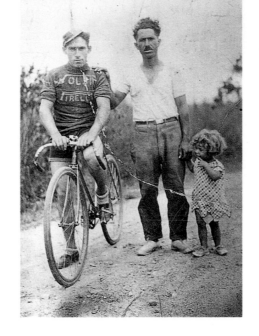

Above:
Erminio the Cyclist
Collection: Queensland University of Technology.
Photograph: Courtesy Queensland University of Technology Art Collection

1905 in Valle, a small town in Northern Italy. A talented cyclist, he won the Tour of Italy and later, a gold medal in the Queensland Championships. In 1956, the Ailis moved to Brisbane where they bought a corner convenience shop which they kept open seven days a week, thirteen hours a day. Erminio began making his artworks around the time of his retirement in 1969, producing a prodigious number of pieces in the few years before his death. On a visit to Italy in 1970, Erminio once told a relative that a 'Lady' appeared to him, telling him to make his art.

As a subject, naive art is absent from the academic curriculum — apart from the study of one of the painters most crucial to the development of twentieth century art, Henri 'Le Douanier' Rousseau. When, in the 1860s, the French avant-garde embraced and fêted the retired customs official and his hallucinatory pictures, the term 'naive art' was born.

At that time, professional academy-trained artists appropriated the style of the naive, seeking to express a rejection of an increasingly complex society which they perceived to be hurtling towards self-destruction. They were suffering from fin de siècle blues — disenchantment, cynicism and satire prevailed. The Academies were choking on their own weary formulas and conventions. The growing popularity and accessibility of photography was eroding the aesthetic value of strictly representational pictures. Artists searched for new ways of seeing. Cézanne abandoned formal perspective. Van Gogh painted what he saw but wrought in his subjects a twisting, bursting animation that flouted the rules. Gaugin, a bank clerk turned painter, found inspiration in the simplified forms of tribal symbology. Sir Stanley Spencer, an

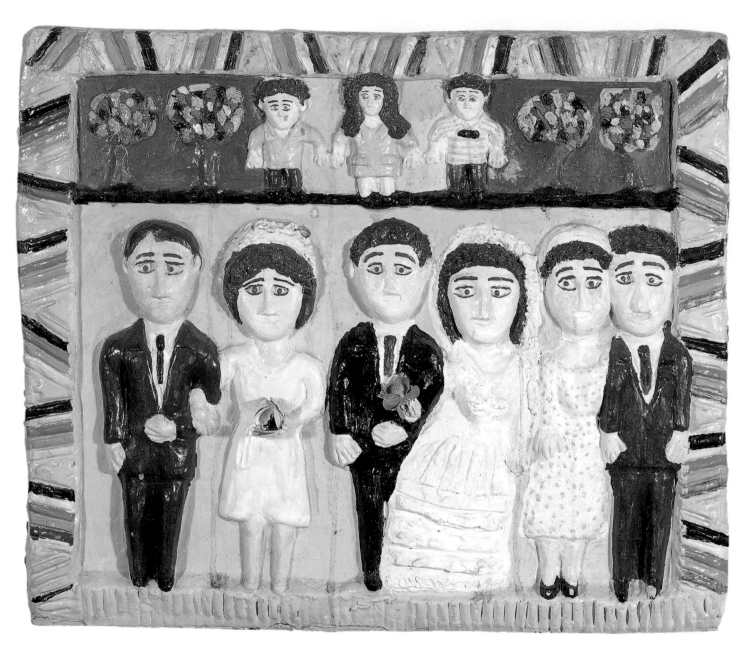

ERMINIO AILI (1905–1975)
Daughters Wedding Group, n.d.
Ceramic
Collection: Queensland University of Technology
Photograph: Ian Poole, Brisbane

artist with a high degree of technical ability and awareness of contemporary practice, approached his canvas with a 'naive' eye.

Modern mass communication has reduced the incidence of the naif who works in complete isolation. Contemporary naifs often do have some kind of formal training or awareness but choose to express themselves in personally distinctive style that can be described as naive.

Rousseau's appeal endures for the same reason naive art is popular today. Naive art tends not to threaten, accost or make cryptic, clever statements. It doesn't make you feel as if you ought to know something more about it than what it represents. It is entirely subjective and comfortably so — both painters and collectors tend to be unconcerned with academic sanction.

Naive art flourishes independent of schools or movements in aesthetic fashion. It is a loose term for a global phenomenon in existence since primeval people described the hunt in ochres on the walls of their cave dwellings. While the professional contemporary artist is concerned with exploration, experiment and analysis, the naif offers a celebration of everyday life, nature, events, memories and fantasies from a palette mixed with candour and humour.

Sandra Warner

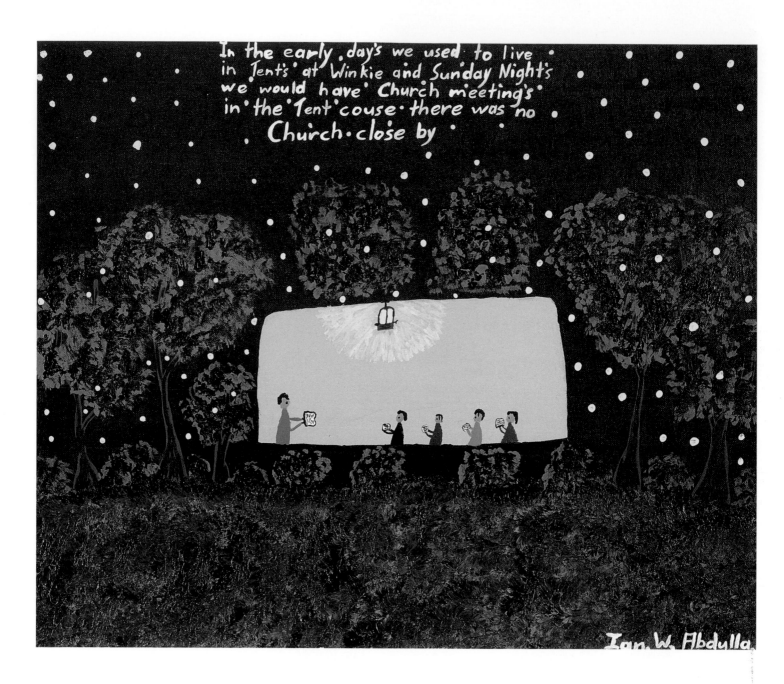

IAN ABDULLA
Prayer Meeting in a Tent, 1991
Acrylic on canvas board 51 x 61 cm
Collection: Tandanya National Aboriginal Cultural Institute
Photograph: Courtesy South Australian Museum

Ian Abdulla

My paintings are about my childhood from when I was six and growing up. I started school at six years of age at Swan Reach, before the 1956 flood came. The mission got flooded so we moved up to the river lands.

My paintings make me feel good because with them I can remember the times of my childhood. The memories come back stronger and stronger now. Now I can teach my children about those times.

In the hard times, my father would catch rats, setting traps in the swamps, and using mussels as bait. At home we'd skin the rats, throwing away the carcasses, and pinning the skins on boards. We'd put them out in the sun and keep turning them over. When they'd dried out a couple of days later, we'd sell them to a bloke in Renmark. He would send them up to Sydney and Melbourne to be made into purses and handbags. The people who bought them never knew they were rat!

We'd go to the local slaughterhouses and buy sheep heads for just a shilling or two at a time. We'd skin them with a double-edge razor blade and then boil or roast them. There would always be fights over the eyes which we thought were a delicacy and when we'd finished, we'd play cowboys and Indians using the jawbones as guns.

Those were happy times, even though we might get only $8 a week in wages along with rations of flour, sugar and tea. We'd find grubs in the ground and frogs at night with torches and put them on cross lines across the river to catch pondi (Murray River Cod).

When I was a boy, we could go wherever we wanted. Now we can't. Parks and Wildlife are closing areas off. Now we have to pay to camp on our own land and that makes me sad.

I take my children out on Sundays and show them wild berries we can eat and how to get water from shrubs. The love between us is the main thing. If you have love for your children, they respond and there are no problems.

In 1988 I went to the Jerry Mason Centre and learnt screen printing under Steve Fox. I started off doing boomerangs and spears, but it wasn't my style. We have a different culture where I come from and so I started painting my lifestyle.

Steve asked me to do something original. So I asked him: 'What if I do a picture and write a story on it?' And he said, 'Go ahead'.

So I never painted in my life until 1989, three months before Christmas. I started off on tiny boards, 10 x 12 inches, and the biggest one is 8 x 9 feet.

I've still got a long way to go. All this hasn't changed me, I'm still the same person. But its good in Barmera where I've lived for seven years, where they say this bloke's famous and they're proud of me. I reckon I'll be sticking with painting for the rest of my life. In the future my paintings won't change much from what they are today.

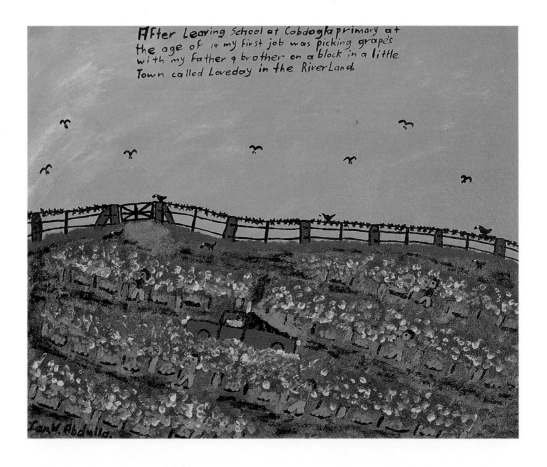

IAN ABDULLA
When we had picked the grapes, 1992
Acrylic on canvas board 51 x 61 cm
Collection: South Australian Museum
Photograph: Courtesy South Australian Museum

John Campbell

I like the 'Abandoned Calf' because it's based on a true story: I found a newly-born calf, umbilical cord still attached, coated with slime, abandoned on the road to Federal one day. There was no sign of its mother, so I took it to a nearby dairy farmer who had a milker to whom it happily attached itself.

Of particular pleasure to me is the appearance in this picture of my two dogs, Wendy (right) and Sally (left). We all love each other very much and you'll have to take my word for it that is exactly how they look.

The idea that naive paintings are, by definition, full of lots of little people doing lots of little things is a little facile for my liking. Henri Rousseau, the greatest painter of this genre, created works full of big people who literally filled the whole canvas. Interestingly, in his 'artist's statement' before one of his exhibitions, he referred to himself as a 'realist'. I do to, for the simple reason that I am attempting to paint reality as I know it, in recognisable living forms. Perhaps this is why my pictures are naive, because I am naive?

I really should be totally honest and admit that I started to paint because I love pictures and continued to do so because I discovered that, at last, there was something I could do reasonably well. I also found that I could express ideas and feelings that would otherwise remain dormant, unrealised even. The solitude of doing the work is good too and when a picture is coming along well, painting itself … I can't describe the feeling.

I have a friend up here called Val who is welding together a thirty-foot yacht under the gum trees in her yard. Bob carves wood. Johnny Helmers propagates seeds that he finds in the forest and grows grevilleas and wattles for nurseries. None of us can articulate the purity we feel, the calmness and satisfaction that our work gives us.

I've done quite a lot of footy paintings. I love Rugby League. I grew up with it and have an encyclopaedic knowledge of it. I love its brutality, its tribalism, its colours, its crowds, its personalities, its for-and-against columns and points tables. But what I really love, and this nobody who knows the game would argue with, is its beauty.

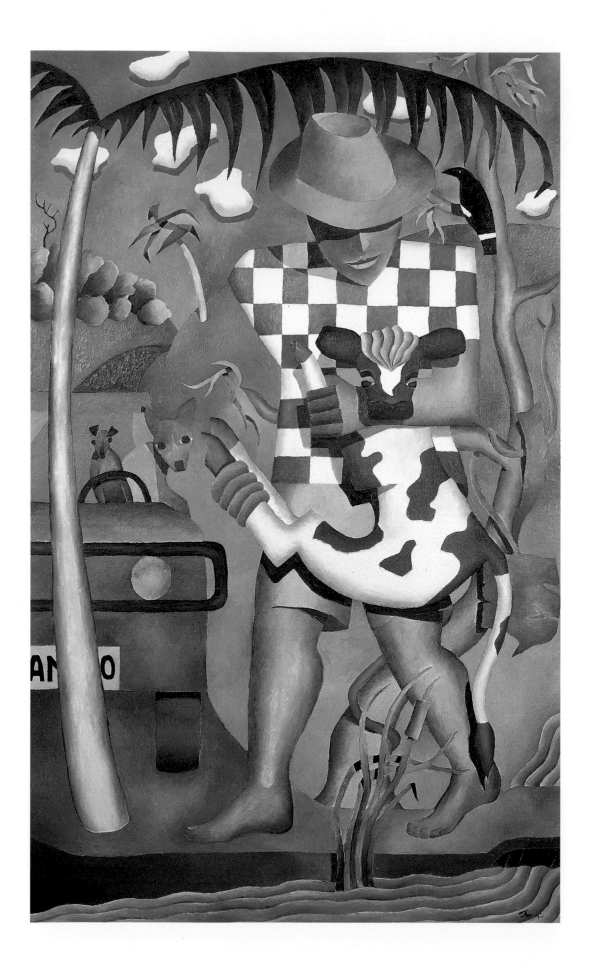

JOHN CAMPBELL
The Abandoned Calf, 1990
Oil on canvas, 170 x 100 cm
Private collection
Photograph: Robert Walker

When it is good it has a fluency, an exactness, a perfection like water finding its level that is ... well, I guess you could say it was like karma. One of my favourite memories is of my old man taking my brother Laurie and me to Henson Park to see the Bluebags play. Coming home I would see them (the team) painted under glass on the wall of the Tempe Hotel, playing St George. 'A man's drink' was the caption. In those days, the early sixties, Saints were flogging everybody in sight and running up a tedious record of eleven straight premierships. I hated the bastards. I played Rugby at Enmore Boys High and League for a park team called the Newtown No Hopers. I was never, and still am not, a very vigorous person, so my career was not a glittering one. But as a devotee, I am a monument to the game.

I think I've pursued the footy idea as far as possible. And I want to deal with broader, more meaningful themes. At the moment I'm doing a painting called *Elisha Healing the Shunammite Woman's Son*. It's inspired by a story in the Old Testament where the Prophet Elisha cures a dying boy by clasping his hands and kissing him. I've done Elisha as a koori and the sick boy as a white Australian. Lilies are floating around (as usual) and in the background are a man and a woman doing a balancing act on a surfboard.

It's near completion and I think it is the best picture of the three I've done in the last few months. The healing of the ailing new world, the boy, by the ancient culture of the koori. The man and woman, also joined at the hand, in a precarious harmony that might at any moment collapse. And, something I have only recently become aware of, the homoeroticism of the two central figures. Though I am not that way inclined I feel great sympathy for gay men living in the awful shadow of AIDS. I have lost a very good friend to this wicked disease and see Elisha's healing as a way of dealing hopefully with that calamity.

I grew up in Tempe and lived much of my life in the grinding heart of grey cities — Sydney, London, Athens. I studied ancient history and archaeology and was indelibly influenced by the art, anthropomorphism and ... something else I can't think of ... 'naivety'? of Egypt and Greece.

Gwen Clarke

How did I start painting? I guess its a kind of magnetism that has followed me right throughout my life, making me feel excited and inspired when I see it or think about it. If I am unable to get time to do it — like the twelve years of nursing which took all my energies — I feel unfulfilled and empty, regardless of other achievements. My life would be meaningless without my creative expression, and this to me becomes clearer as each year passes. So my reason to live (apart from enjoying all that exists in this wonderful country) is to paint, to create and most of all to leave something behind when I die as a record of how I see the world.

My main intention is to create this 'other world' of colour and design. I'm inspired when I'm not worried or tired. I look at the world through the eyes of the artist and see everything as potential subject matter. I take from nature what I choose, and make it my own. Landscape predominates in my work. This is not deliberate or intentional. It just happened. I may have chosen it as a stage on which to place the figures and animals I love. Also I notice I paint Australian wildflowers as part of the work in many paintings. I am a very keen gardener and I adore flowers.

GWEN CLARKE
The Donor, 1987
Oil on board 30 x 50 cm
Collection: Nursing Archive of Australia
Photograph: Bob Iddon

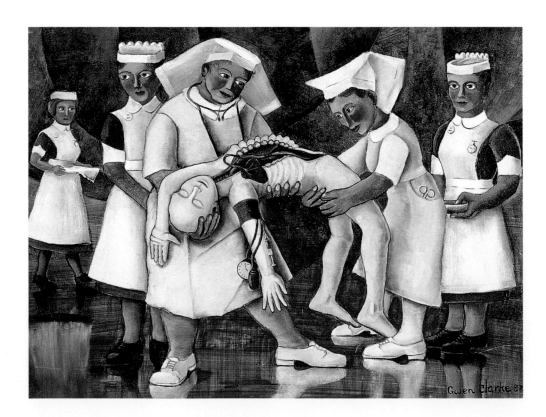

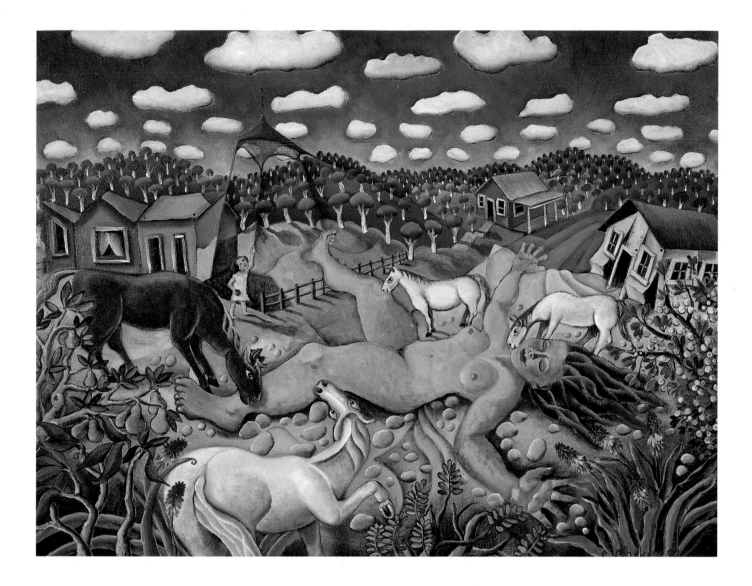

GWEN CLARKE
Nude in a Landscape, 1992
Oil on board, 34 x 44 cm
Collection: Etienne Cohen
Photograph: Robert Walker

In 1991 I moved to Bairnsdale after 37 years in Melbourne. It's close to where I was born, and I am delighted to be back in the Gippsland I love.

I was a member of the Victorian Artists Society for about one or two years at the time *The Donor* was painted. I entered it in the Victorian Arts Society Spring General Exhibition over which a selection committee presided. The day I took it in I well remember as the works were all placed leaning against the wall in readiness to hang and in the subdued light I glanced about and saw mostly landscapes in the tonal impressionist Max Meldrum style. No doubt there were others but my painting as I left looked isolated. Anyway I was quite happy to leave it and thought it would be a contrast, but never believed it would be totally unacceptable.

I soon found out it had been rejected and banished to the storage room where I very quickly came and rescued it. I remember I was so angry on that day I could have kicked the cat! The conditions of entry were 'one's very best work' of which

this was, I considered. I could do no better. I felt it was highly original and straight from the imagination, using no props or models at all. I came to the conclusion that the subject matter shocked the socks off them. I was glad.

The patient is about to be parted from his heart. It is during the time of early heart transplants where the donor had to be declared 'brain dead' but the body still functioned. My thoughts on this, even though I understand it in a medical way as a nurse, I still as a person cannot accept what has to happen beforehand, before a recipient can have the wonderful gift of a new heart. The team who have to be trained to go anywhere to harvest the hearts remind me of the grim reaper, total death.

Of the two sisters in the painting, the one on the right represents me, scissors in pocket and white stockings. The trainee nurse on the left also represents me trying not to look. In actual fact I was in training and also a staff nurse while I was at the Queen Victoria Hospital. The trainee uniforms are authentic, mauve and white with all the cuffs and collars stiffened and worn separate, grey stockings and black lace-up shoes. They also wore name badges on the right-hand side.

Of course this painting is a fantasy. You would never see this scene in actual hospital life, but it is to show the vulnerability of the unconscious person, and what nurses are called upon to endure.

I can't say much about *Nude in a Landscape*. It's a spontaneous painting. It just evolved. I wanted the woman to encompass the whole earth. It comes from the feeling of freedom I have here in this beautiful place of Gippsland, my birthplace. If you could see where I live — acres of grasslands surrounded by tall timber trees which have been left to grow on the roadsides, forming wonderful windbreaks, and the wind sounds like the ocean as it roars through them some days. The undulating hills go off from farmlands to forest — complete and absolute nature and I can't express how grateful I am to actually be here after 37 years of city life, so cut off from this, what I need to live.

I have a garden after eight years of none and I am obsessed with growing things like the red-hot pokers in the painting. So the painting is really how I feel about here, so extended and in love with the land.

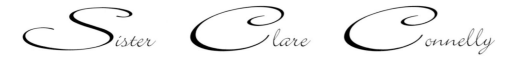

Sister Clare Connelly

I was born at Westbrook near Toowoomba in 1930. There were six children in our family including two sets of twins. My brother and I were the eldest. Westbrook is on the way to Pittsworth, just outside Toowoomba (Queensland). We had 60 cattle and 160 acres. I enjoyed being on the farm. I used to help Dad do the stacks — that's build the haystacks. It was hot work but it was fun. And the milking. We milked eight cows each in the morning and eight at night. We'd have to come home from school at three o'clock and milk. You have to milk cows at the same time every day otherwise they hold their milk. Sometimes I'd get up at three o'clock in the morning and help Dad because he was a pastry cook as well. He worked the farm after Grandfather died. My grandparents were a great help because while Mum was milking when we were little they used to look after us. We used to ride a horse to school. Five of us on the horse!

I was a tomboy. I used to play football, cricket and rounders with the boys. We also rode horses. Every Saturday my brother and I used to play polocrosse. We were in the team. I played for about ten years before I went to the convent.

Life on the Farm — Westbrook, Qld. In this picture, Dad's taking a calf to the sale — he's got it over his shoulder — and this is him milking a cow; and that's the cow yard in the olden days. In the middle, he's trying to sell the tractor and my brothers are standing around him. Our mother and sisters are just outside the house. That's me on the bike. The grass is blue there to give it a different colour. It was clover and a bit longer. At the top of the picture is the dog who used to jump up on the horse, and Dad. He's waiting for the truck to come and take the cows to the saleyards. There are our two dogs and the cows, the bull and the sheep. I put a lot of paint on those sheep. It was before shearing time.

In the beginning I didn't know I could paint. Once, in my noviceship, a sister came out to teach art. She gave me up as hopeless. I know why — no perspective!

It wasn't until 1977 when I went to Kedrun College to update my teaching and art was one of the subjects. Bill Robinson took the art class and he asked us to do an acrylic painting. I did mine back at the convent and when I took it in he said, 'Oh my goodness! Look at this! You're a true artist! A true naive artist!'

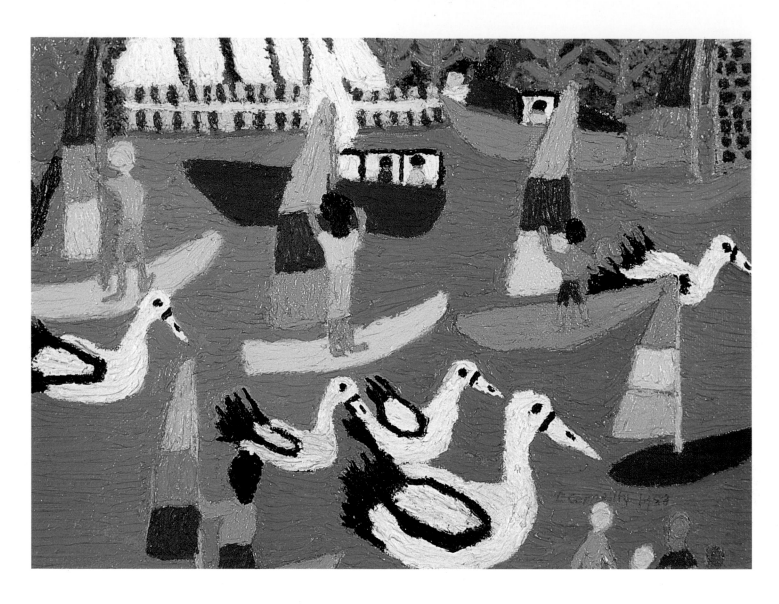

SISTER CLARE CONNELLY
The Broadwater — Southport, Qld, *1990*
Oil on board, 23 x 30 cm
Collection of the artist
Photograph: Martin Jorgensen

Naturally I didn't believe it. Then he wouldn't teach me! He said it would spoil my style. He was very good. And I got 7 out of 7 for art right through college!

I sketch the picture onto paper first, then I draw on the canvas and paint it. I don't get much time to paint. Only an hour or two. Then I have to go and drive the Sisters. I'm a driver here at the Convent, so when the Sisters want to go somewhere, they book the car and I drive them. Sometimes if I'm not going out on a Sunday I get a pretty long stretch, but that's few and far between. I can take two years to do a big painting.

I just paint what's in my mind. I don't measure. With my eye I can see what shape to do.

I rarely have trouble thinking up pictures. Most of the farm ones are memories from when I was growing up or from when I was teaching as a nun at Mitchell and Cunnamulla and the other teachers and I were invited out on the stations. When I was at Cunnamulla I went out to a cattle station when they were dipping and branding the cattle. I did a painting of it. The cows in it are looking very worried about being branded!

The Broadwater — Southport, Qld is from when I was living in Southport and teaching at a convent on the Gold Coast. One day I sat on a seat just near the Broadwater and there were people sailboarding around and pelicans and on the other side of the water, the sails of the yacht club. While I was sitting there sketching, a boat went by so I put that in too.

Sometimes I don't know how my pictures are going to turn out. I just put things in all together and fix it up as I go. I've painted a horse jumping over a house. I didn't know it was going to turn out like that. I didn't mean it to! I had a giggle about that! After I'd done it I thought it looked good! I really enjoy myself when I'm painting.

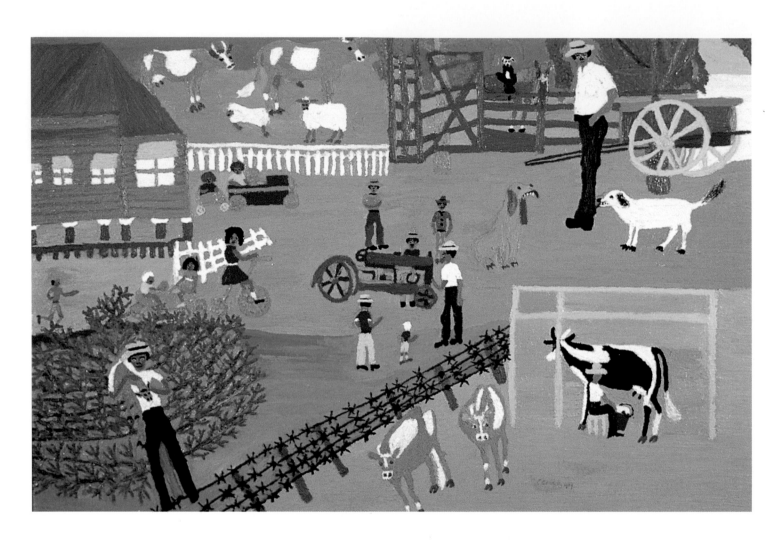

SISTER CLARE CONNELLY
Life on the Farm — Westbrook, Qld, *1989*
Oil on canvas, 61 x 91 cm
Collection of the artist
Photograph: Martin Jorgensen

Stephen Convey

I was born in 1950 in the inner Melbourne suburb of Prahran. It was an interesting area in those pre-trendy days. There were half-a-dozen cinemas within walking distance of our house and we made full use of them. The bread was still delivered in brightly coloured horsedrawn carts. We would run after them and if we were lucky, the driver would throw us freshly-baked rolls.

We spent hours watching the blacksmith at work in a lovely old bluestone building which, sadly, has now been demolished. Our pocket money was earnt by collecting beer bottles which we took to the local bottle-o at the end of our street. Collecting newspapers was another way: they used them to wrap the fish and chips.

I was educated by the nuns and Christian Brothers in neighbouring St Kilda. School wasn't my favourite place. The rigid discipline and dogmatic teaching didn't appeal to me and by my teenage years girls and rock'n'roll had taken a firm hold. I left school after third form and started my first job at Myer department store as a stock boy.

Music has always been a big influence on me: the rock'n'roll of Little Richard, Buddy Holly, Jerry Lee Lewis and also the lonesome sounds of Hank Williams and Lefty Frizzel had a strong emotional effect. I have always been a seeker and started tracking down all the influences on those people and many more. I realised this is a never-ending quest and one that I am still pursuing.

After leaving Myer, I had a succession of jobs — mainly labouring. During this period, I hitchhiked to Sydney with a friend. We had been reading Jack Kerouac and the rest of the Beat writers and had visions of criss-crossing Australia and finding knowledge and enlightenment on the way.

We wound up in Kings Cross for a few months, living in sleazy rooming houses and on hot dogs and fried rice. It was a lively place at the time mainly because of the Americans on R & R from the war in Vietnam. We mixed mainly with petty criminals, transvestites, prostitutes and street kids. It was an interesting time and on reflection, we learnt quite a lot from the experience. We headed back to Melbourne with just enough for our train fare.

The next couple of years I spent working as a casual labourer in the Melbourne railway yards. It was a great place to work due to the different array of people who worked there: itinerants, musicians, junkies, alcoholics, writers, uni graduates and other assorted eccentrics.

I was married at 21 to a girl I had been living with on and off for a couple of years. The marriage didn't last long — we were both too young. The best thing from the marriage was the birth of my first son, Matthew. I gained custody and proceeded to raise him on my own.

Soon after I met Suzie, my present wife. We had met briefly as teenagers and our paths crossed again through mutual friends. There was a strong attraction between us and we started living together in a house in Camberwell with another couple in similar circumstances. I had been working on the Melbourne waterfront as a tally-clerk for the last four years, working rotating shifts in a container terminal. It was similar to the environment in David Ireland's *The Unknown Industrial Prisoner*: a nightmarish, surreal locale surrounded by cyclone fencing and petrochemical plants.

Suzie was artistic and used to do a bit of drawing mainly elaborate hand-drawn birthday cards. She had an old set of Marvy Markers — Japanese textas. Suzie encouraged me to use these. I had made a few attempts at drawing and painting but I wasn't pleased with the results.

By this time, we had moved to a place of our own in nearby Surrey Hills and had a baby girl called Skye, a playmate for Matthew. Life was starting to become difficult for me around this time. I was experiencing severe anxiety attacks and having trouble sleeping. I started meditating and walking for miles to try and get some balance in my life.

One night, after a bad time at work, I went for a walk to a local park and came across a tree that was shining and vibrating. I had never experienced anything like it before. It revitalised me but also scared me.

Work was really getting me down: I had nothing in common with the people I worked with. They were mainly relics from the '50s Cold War mentality and I was full of optimism and change. It was becoming harder and harder to keep going. I was

STEPHEN CONVEY
Full of Joy, 1990
Acrylic on board, 123 x 61 cm
Collection of the artist
Photograph: Robert Walker

continuing with the meditation and walking and starting to have weird experiences such as seeing ghosts and all sorts of spirit-like entities. Things were getting out of hand.

One night, after being at a friend's house in Malvern, I walked off after a disagreement with Suzie. I wound up along the banks of Gardiners Creek in Heyington. It all seemed predestined. I took my watch and rings off and took all my clothes off and swam across the creek. As they say in the movies, I was making it all up as I went along. The magpies and wattle birds were talking to me. It was approaching dawn by this time and the trees and plants were also communicating their thoughts to me.

After the immersion, I decided to find my clothes. It turned out I couldn't find them and proceeded to walk back to my friend's house naked. The police picked me up one block from his place. The next thing I knew, I was being transported in the back of a divvy wagon to, horror of horrors, Larundel Psychiatric Hospital. My parents had committed me. I was given strong tranquilisers and placed in A Ward — a locked, overcrowded ward full of men and women swarming around praying, screaming, crying ... total chaos. I did a few crayon drawings while I was there and the doctors had obtained some from my family and proceeded to ask questions about what they meant.

It took a couple of months before I was allowed out again and I resumed working. The usual comments were thrown up at me by some of the more insensitive people I worked with, but it soon died down. I was drawing continually by this time. It seemed as if I had reached a place deep within myself that would stay with me forever, the primeval source if you like. All my work is spontaneous. I have a blank board or piece of paper and just start and the images come together.

I still work on the waterfront, but in a different location and only during the day. We have four children now, two boys and two girls, and live in the outer eastern suburb of Ringwood.

The first exhibition I entered was in Sydney. Tony, my brother, talked me into showing some of my work. He has always encouraged my art. I just want to continue painting, drawing, sculpting for the rest of my life.

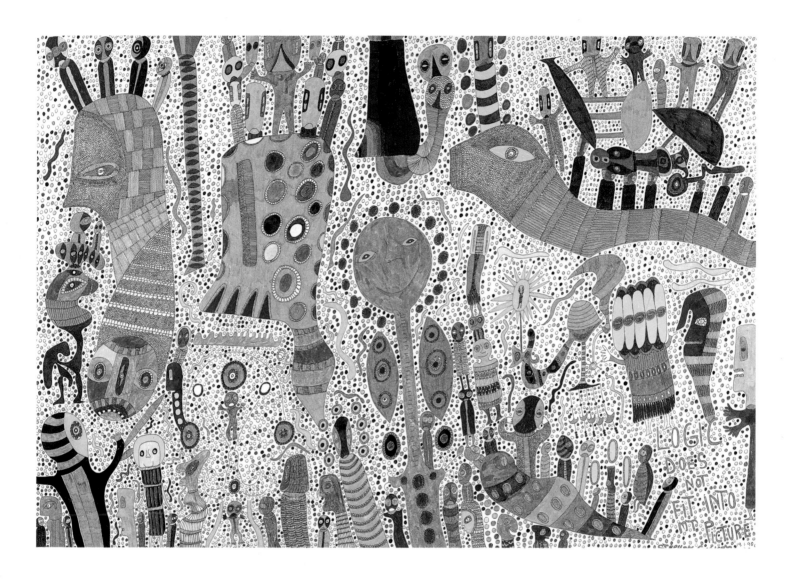

STEPHEN CONVEY
Logic Does Not Fit Into My Picture, 1990
Mixed media on paper, 61 x 86 cm
Collection of the artist
Photograph: Robert Walker

I've drawn as long as I can remember. I would draw on the blank pages of my parents' books. I always see things in a figurative way: even patterns become figurative. I love fabric — it gives me a sense of security, of comfort. I like going to fabric shops and finding unusual pieces of fabric. It's obviously a female thing, going back to my childhood and Latvian costumes, beaded and embroidered, that the dancers used to wear at festivals. The excitement of a festival and the colours. That sort of fantasy and magic.

I arrived in Australia as a very young child and I've had the two cultures to deal with. I went to Latvian school on Saturdays as well as five days at a normal school. The other kids used to think it was some sort of torture that I had to go through, but it was a great pleasure learning about this magical country that I'd never set foot in. My parents fled Latvia after the War and I was born in Germany on the run.

I spent a lot of time with a couple of elderly Latvian poets after my Dad died: dark rooms filled with books and the stories they told me still linger in my mind of the folk lore. A lot of it was based on animals. The folk songs were really beautiful too: they spun stories, threads of the type of life they led.

I was influenced most by the stories I was told. The young women, the stories of the horrors they went through in the War. That dark side erupts every so often in my paintings.

I don't sit down and think, 'I'll do a series of such and such'. I probably work better under pressure and I always cause that sort of pressure. I hate pressure, but it seems to bring out the best, most spontaneous part of my work.

The closest I came to doing a series was when I did *Hair of the Dog*. I actually used the dog in every drawing and painting and print. It was just something to hang it on — and I did it in a humorous way too which I do with a lot of my work. Even though there's a serious message, it takes the edge off. I twist them around at the end and turn them into something quite funny. Other times something I thought would turn out funny would turn out very serious and pensive.

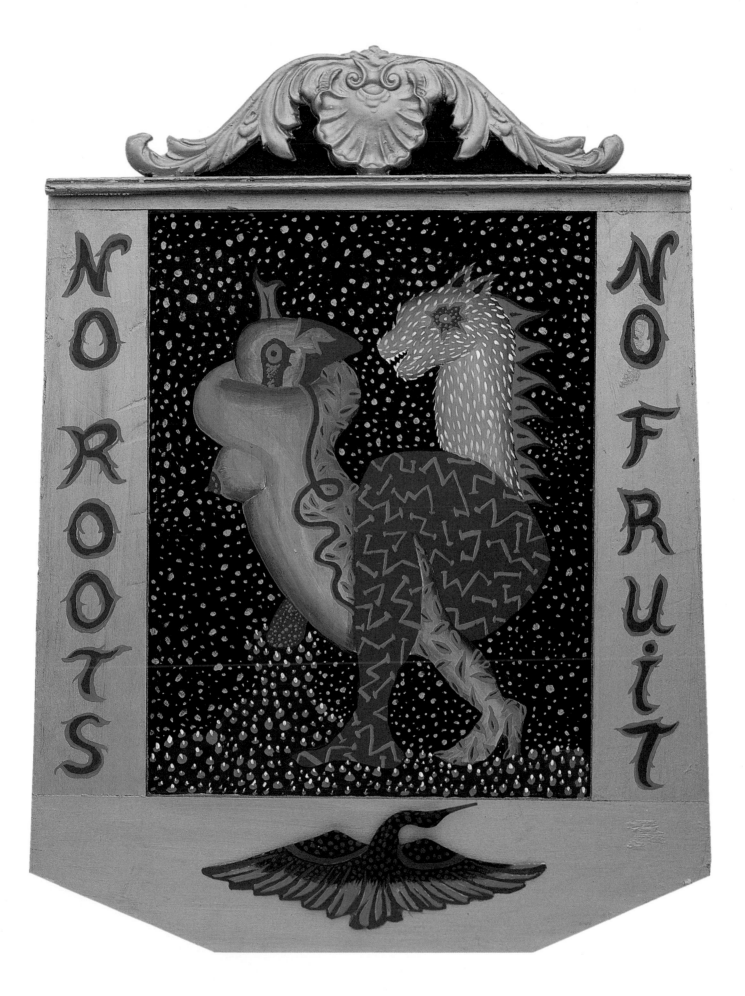

SYLVIA CONVEY
No Roots No Fruit, 1992
Mixed media 53 x 41 cm
Collection of the artist
Photograph: Robert Walker

A lot of my work relates to our rural life in north-east Victoria too because that was probably the happiest time: watching our four sons growing up. It was a time when we took lots of photographs and films and had lots of holidays and get-togethers.

The pleasure of human links. I did a lot of paintings of mother and child. That has come out a lot in my recent paintings too. Basically oriented around the female. I have to paint the female. I am a female.

Painting is a compulsion. It's like something in my mind is going to explode unless I express it. You can do all the mundane things but you don't actually feel right in the head until you've actually made that picture or done that drawing.

Even when I was trained, I wasn't interested in critiques in newspapers or art magazines or what was current. We would go off to see Biennales and Perspectas and very little of that had any impact. It was wall-to-wall art but very little of it had much to do with what I was painting. I felt really pressured, and I was pushed in certain directions. When I started the abstract thing was dominant. Even though there's abstraction in my art, I'm still a figurative artist. I remember being forced to paint four abstract paintings and I did it in the backyard. The cat walked across it. They were really pretty colours.

I took them back to art school and everybody looked at them but the art teachers all talked about them formally. I had to make fun of it in some way, so I suddenly said, 'God, they're all upside down!' That blew their whole composition analysis. They were in fact upside down. To me it really didn't matter they were like backgounds to paintings. I use them anyway. But I have to put a figure or creature or some living spirit into each of my paintings.

I think my art is a rebellion against the way I live because my life is really crowded: I've always been surrounded by people. The feeling, when I do get a bit of space or some time, of being in a room for a couple of hours on my own, is really precious. I can breathe and relax and I don't have to worry about everybody else and everybody's problems. You need to keep something for yourself. I've always needed to keep something in my paintings for myself. Even though they're hanging on a wall open to the public.

I did four boxes for the Coloured Life exhibition with lights flashing on and off; they were like little theatre sets. That was the exhibiton where I had 3D glasses, too. I put in every different media I work in — painted furniture, quilts, sculptures, the masks the people actually put on with the 3D glasses at the opening to look at the work.

I'll always move betweeen one medium and another. They affect each other. I try to marry my loves together; drawing, painting, and fabric.

I often paint women surrounded by creatures. Those creatures move from one painting to another. They're very crowded, very hemmed-in paintings.

No Root No Fruit started as a drawing I had tucked away in one of my tiny pocketbooks. Again, it's creation I suppose and a naughty, whimsical play on words. The frame's got a bird coming out of it and it's one of the few paintings that I've done with words writtten onto the frame. I did another one called *Stop Putting Words in My Mouth*: a female figure, with a male and a female on her shoulders, pouring a fish out of her mouth.

I do a lot of erotic paintings. One of them was bought by a hotel for their Honeymoon Suite! The first erotic etching I ever did, *Starry Night*, was a sell out. That's part of life, too. And it's fun.

I only became a painter by chance: my wife Sylvia painted and I'd never been exposed to art before. It had never come into my life. Watching her work had a mysterious effect on me, I was intrigued: I thought, this is something I could do myself. Something deep inside me responded to it. Sylvia could see that and she encouraged me gave me, a canvas board and some paints.

One saturday afternoon I sat down and did my first painting. It was a crude image of a bird and this bird took flight and changed my life! I've been painting ever since.

I seem to do two kinds of paintings: the more prevalent is the narrative, like my mining pictures. They're usually the result of long meditation on particular places and people. We lived in the mountains in north-east Victoria for many years and the mosaic of human activities overlain on that landscape: by the Aboriginals, the goldminers, cattlemen and explorers, gave me an inexhaustible pool of images to explore.

Old ghost towns like Sunnyside weave a potent spell. The magnificent physical setting itself, the granite pinnacles of Mount Wills looking over across to Kosciusco give the place an unforgettable feel. Something of the spirit of the people who lived there still lingers. They obviously took great pride in their gardens: there are still traces of old gardens and the daffodils, jonquils and snowflowers still bloom every spring.

One painting I did recently was of *The Great Comet at Sunnyside*. I talked to an old man who had been born at Sunnyside. His father was a miner and he told me about his life there and how hard it was but also how much he'd enjoyed it as a young boy, being in that wild place. He told me about seeing Halley's Comet in 1910: how his mother had held him up and shown him this great wonder streaking across the sky. He also remembered that it seemed like a portent at the time, an omen of bad prospects for the town and indeed it turned out that way because only a few years later World War I started and that effectively killed goldmining, certainly in those isolated areas.

I've tried to concentrate on the human side of goldmining, the folklore, the characters and their unique lifestyles. The way they merged into the landscape,

TONY CONVEY
Animal Magnetism, *1988*
Oil on wood and metal, 63 x 63 cm
Collection of the artist
Photograph: Robert Walker

even though they're long gone, they still haunt the landscape. The sense of Aboriginal presence is strong: you'll be scrambling up a gorge and come across a spearhead that looks like it's just been left. And it's been there for hundreds of years.

The area has had a vast effect on my work. I don't think I'll ever stop exploring this rich material. In fact the whole Great Dividing Range has had a big influence in my life. I've lived in it and next to it, not only there in Victoria but also here on the other side in the ACT. I spend many hours exploring Namaogi National Park and the Brindabella Mountains and I've depicted some of the folklore of this side of the range as well.

The other kind of paintings I do are more spontaneous and arise either from my subconscious or what people have called the 'collective subconscious'. The metaphysical emanations of mankind. I don't know where these images come from. Perhaps they are very early memories of childhood. I don't know.

Sometimes when I do paintings like *Animal Magnetism*, I finish the picture and look at it, and I'm quite shocked: the images seem disturbing and have a power which is simultaneously attractive and repulsive. They have a quality which is difficult to put your finger on. I don't do as many of these paintings, but I look upon them as gifts, because in a way painting is a quest: it's a process where you try and surprise your-self, come up with images you haven't seen before and when you do succeed in casting up these unexpected, unexplainable images, it has a euphoric effect on you.

A lot of them are concerned with animals either recognisable animals: marsupials or cats or other ambiguous creatures. Anyway, animals seem to be a preoccupation, particularly in my drawings. I draw every day. I have scores of notebooks with drawings in them and every time I look back through I'm surprised at the number of drawings which centre on animal imagery. I don't know why this is. I've always had pets, always been comfortable in their presence. I don't know whether I use them in a symbolic way — whatever, the image of The Beast is an essential part of my work.

I love patterns and details. The closer you look at anything in nature, the more patterns you see. For me, the more patterns and rich, textured surfaces, the more life in the paintings. My paintings have to seem to be alive to work. If I produce a painting that I don't think I've brought to life, I usually destroy it.

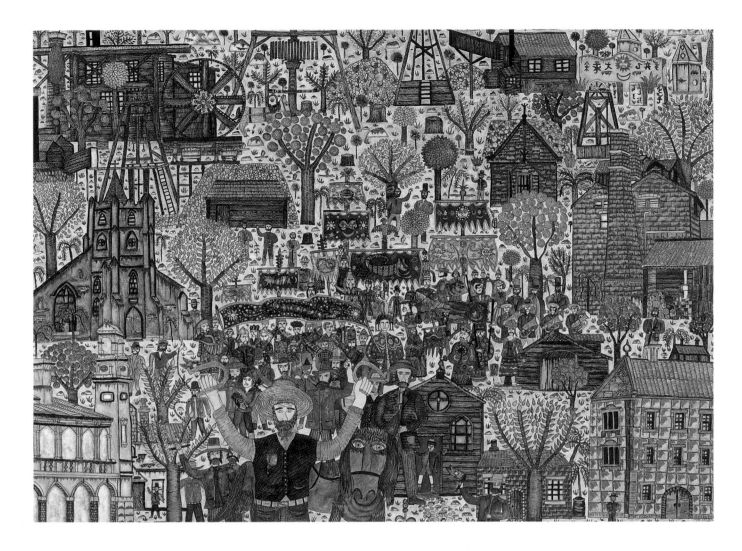

I don't know how to define what I do, although I really believe that I am, in the accepted sense of the word, a naive artist. I think that naive art relates more to the heart than to the intellect. What distinguishes naive art from academic art is that the mainstream artist works from existing models or styles and the naive artist makes up his own style as he goes along. He's just trying to express his reality the way he sees the world and the technical aspects aren't a conscious concern. I think the main concern of artists like myself is to tell stories and share experiences and memories.

I'm always trying to work with different materials so that the actual process never becomes stale, never becomes a formula. That's why I often use found objects. I suppose it could be a way of going back to our rural life in the Mitta Valley. I enjoy making images out of rusted iron, and lichen-encrusted wood that I find in the paddocks in the areas around the Molonglo River.

TONY CONVEY
The Golden Horseshoes
Beechworth, 1855, *1985*
Etching, hand-coloured. Edition 6/6
45 x 60.5 cm
Collection of the artist
Photograph: Robert Walker

In all my work I've tried to express a love of life: people, animals and the beautiful surface of the world. I get great pleasure from describing the surface of things. And at the same time, I've always tried to instil in my work a feeling of mystery because mystery is one of the essential elements of life. We don't know in our personal life what is around the corner or what is our ultimate fate.

I get a great deal of pleasure out of the physical act of painting: using paint and brushes and watching the images emerge from the paint. I work outside almost exclusively. My garden's my studio. I have a great view of the Brindabella Ranges.

The act of painting is like a journey: you start out with a few landmarks and then you plunge into the unknown. You never know what's going to come out of the process. I see life as a wilderness, a mysterious place and my little path through it is my way of making sense of life and the mystery of the world. And I'm really grateful that I have a way of making something of my experience that can be shared by others.

Phyl Delves

I've got to paint ... it's a part of me. I find it hard to explain.
People say 'Oh, no! Tone those colours!' But I can't live without colour.

I do the crayons. I get an inspiration and I've got to do it, I've got to put that down, so it's quickly done, on a sketch pad with crayons. Then it's there for whenever I can go to it.

There are times when I feel a bit depressed. The only way is to go and start to paint. Every care disappears. It was only yesterday morning, I was doing a little bit more to *The Tigers in Dad's Backyard* and three hours had gone before I realised it! That's how I've got to paint.

I started doing oil painting when my son Paul was about 8. So I've been painting for 31 years.

I was so nervous. I had been doing crayon sketches in a scatty way, nothing serious, and then I went to the TAFE at Muswellbrook where I was introduced to oils. I went because of Paul, being the only child: I thought, I can't be possessive with him he's got his own life and I wanted to be prepared for the time he left home. I wouldn't be saying to myself, 'I'm hard done by, my son's gone'. I've got adventure too.

This urge for painting was always there. When I was going to school, there'd be afternoons of painting time. I felt that my paintings weren't good enough, but there'd be a little prize in some of the classes, it might be an apple or orange. I used to think the teachers were feeling sorry for me.

I didn't have the self-confidence. I always looked on my art as being something inadequate. I was intimidated — people expect it to be photographic. I think then you're defeating the purpose. I realise now, that although I still think people who can do it are very clever, now I am beginning to value my art myself.

I have this horrible self-consciousness about it. When I go out sketching, I much prefer to be alone. At Ballina, I'd go out and find these secluded little spots and sit

PHYL DELVES
Ballina Shores, *1967*
Oil on board, 41 x 46 cm
Private collection
Photograph: Robert Walker

on the rocks. Very uncomfortable of course! I was never organised enough to bring a cushion. The urge just takes me and I rush off.

As I'm painting, there's a magic feeling around me. I know it sounds crazy. The world is so beautiful and there's so much tragedy— you've only got to listen to the news but I think I've been looking back, picking out what's been beautiful in my life.

Life for me as a young person was very hard because I had the rheumatic fever. When I was nine I missed a whole year of school through rheumatic fever. In those days they said rest was the only cure. I'd see my friends going to school from my bedroom window and I just wanted to use my feet. Now, when people complain and say they're getting old, I think I'm so lucky because I can put my feet to the floor every morning and I can use my hands. It makes you value life. The colour I put into those paintings is life. It's exciting. I don't know whether that's right, but I just love it.

I put *Ballina Shores* into the yearly art prize in the second year I was at Muswellbrook TAFE. Helen Sweeney was the art teacher as well as art critic for the *Sun Herald* and she gave me a prize for it. When it was announced, I was up the back of the hall, and people turned around and congratulated me and I didn't know what for! I was just plain dumbfounded! My photo was taken with the Mayor of Muswellbrook and Helen. I just could not believe it! I couldn't sleep that night I was so excited.

They gave me great encouragement at Muswellbrook TAFE. I was lucky to have such wonderful teachers. One was Hermione Gilliam: she had the most gentle way with her, and Ruth Berry was the next. One night, the teacher put a big sheet of brown paper on the blackboard and asked me to do my painting on it. The rest, they had their paper on their easels, but she put mine on the blackboard! It was huge! I was so humiliated because everyone could see my work, but they had theirs hidden behind the easel. The teacher sat up the back on a stool watching every movement I made. She was a high school teacher, and she asked me to bring some pictures up to her at the school and she sat in her office studying those paintings. I said 'You want me to give up', and she said, 'No don't ever give up! You're a true naive'!

I didn't know what a 'true naive' was. I just knew I wasn't the same as the rest of the class. Then Max Watters started coming two or three times a week to my place

because the TAFE teachers told him I wanted to give up. They were fun afternoons: Max would be saying, 'You've got to paint!'. When he had his cup of tea, he'd say, 'Where's the painting? Where's your paints?' And he'd put the paint on the brush and he'd say, 'You will go on.' And the hatred! Oh, dear I hated him! I thought 'How dare you tell me to go on when I'm just a hopeless painter'.

We moved to Wagga Wagga from Muswellbrook. I did paint, but I took up creative embroidery and got very involved in that. I did feel it helped me a lot with the painting with texture. I love to use the palette knife and have texture in painting. So I didn't do a lot of painting there but I kept sketching. Wherever I went, the sketch-book went.

Then from Wagga Wagga to Newcastle, and that's where I got back into painting because Douglas decided on the home we're in because it had that area downstairs and he said 'Phyl, there's your little gallery'.

I will just drop household chores — I because as I say I should have been making Paul's bed when I painted the autumn one in the living room. I opened the window to make his bed, to air the room and there was that fog breaking and no way could I go on with it. I suppose that's irresponsible. And I never pack a port without putting the book and the crayons in. So I can't possibly be organised housewise, but I've got such an understanding husband. So long as I am happy, Douglas is happy. That's been such a great help to me.

I can't paint without getting some paint on myself. And Max Watters used to say to me 'Gee, you are a good looking woman!' and Max was so aloof: it wasn't like him to give compliments and I'd look in the mirror and I'd be all warpaint!

But this is all part of it, and when I go to bed, I'm so relaxed, it's like being in a sort of fairyland I get so absorbed in it, and then I'll go to sleep and I'll wake up and think 'I know what that painting needs!' And out of bed I hop.

Edith Dunstan

I paint only when I have inspiration — received in many ways. Sometimes music, sometimes religious convictions, sometimes significant events. My means of painting has been evolved, and now I put drawings (which I do for each painting) onto canvas by means of 'transtrace'. This is fairly new to me; all methods are lengthy. I haven't found the perfect way to do it yet.

I first got the inspiration for *We are the Children* from the work that Bob Geldof did on behalf of the people of Africa who were in dire straits at that time. A huge concert was arranged between London and the USA and various artists took place in this concert and gave their services free. The admission prices were donated by the management of the Wembley Stadium to the cause of African children.

I watched the concert on television and I had been thinking I'd love to do something in the way of a painting from that and I decided I'd like to do a painting including most of the artists of whom I happen to be a fan. It was a wonderful concert and much money flowed to that cause as a result of the concert.

Bob Geldof is at the bottom left-hand corner looking very dubious wondering whether it's going to work out. At the very bottom are the brown hands which come together, forming the applause of the concert and there's a little brown baby next to a little white baby (my grandson!) And Bob Geldof once again, walking across the stage with a huge newspaper, hoping everything will turn out right.

Then up to Diana Ross — I'm a fan of hers — and Ray Charles is the one on the right on the same level as her, just sitting down starting to sing. Then there's the guitarist — I don't know his name and the pianist — I don't know his name either. And the drummer you can see just behind Diana Ross. The yellow lights are all footlights. Molly Meldrum's sitting in a box-seat over there on the left and next to him there's an item being sung by Tina Turner and Mick Jagger.

At the very top there are little cherubs and angels because, after all, we are the children: that's how we're going to end up, so we should remember that, in this appeal for Africa. The angels in the blue windows are just my ideal of little angels flying about and so forth. Above them are the spirits of children flying joyfully off.

EDITH DUNSTAN
We Are The Children, 1985
Acrylic on board, 91.5 x 61 cm
Collection of the artist
Photograph: Robert Walker

Iris Frame

I am a Living Legend Artist in my own natural life time ever since 1975. I am the World Wide Greatest Natural Born Artist Naive. I am an outstandingly Gifted Born Artist. I write two letters at a time, one each hand. I sketch both hands at the same time. I have done (so) before a large crowd in (the) City of Adelaide.

My little Wild Aussie Families are World Wide Greatest attractions. The Penola Wild Aussies are (called) Little Wood Charlies. They have their own song, 'Penola Wood Charlies' Waltz'. Another Wild Aussie Family are the Sharra Sharra Wirra Wirra Lees who turn the lake blue. They dance in the moonlight to the Mount Gambier Waltz.

My Lands of Fantasy Fantastic Art Galleries (at Penola S.A.) Are the biggest Private Art Galleries in the World that is All done by one Artist, Myself. At Present I am painting a very Special Commissioned Painting for Adelaide North Terrace Government Art Gallery.

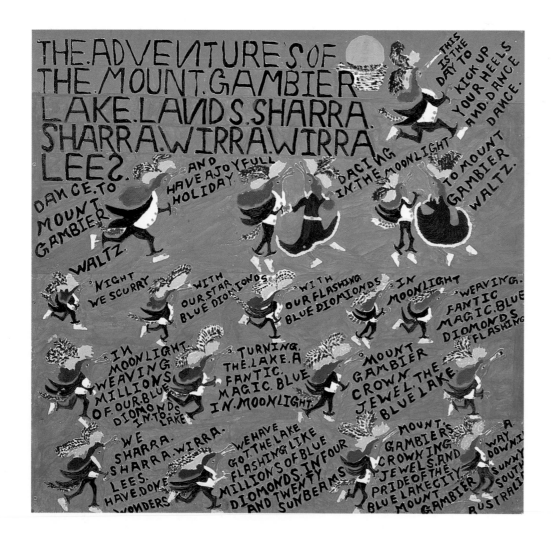

IRIS FRAME
Shirra Shirra Wirra Wirra Lees, n.d.
Oil on composition board, 56.9 x 56.2 cm
Collection of the artist
Photograph: Courtesy of the artist and Riddoch Art Gallery

I hope you get as much Joy and happiness for being one of My Art Fans as others do, according to My Tourist Report Books which say that My Art Shows clear up Stress Headaches, Heartaches, Down in the Dumps and Chase the Blues away. The Public from around the World Just Love and enjoy My Lands of Fantasy Fantastic Art Galleries Joy World. The Joyful happiness that My Art gives to Public People is unexplainable. I have watched the Public at My Art Shows, trying to find out just what it is in My Art that Makes people so happy but so far its unexplainable.

I am an Extremely Natural Born Talented Artist as All City Art Gallery Directors will tell you. I am Classed By Art Gallery Directors as a great find in the Art World. My Art is Classed Treasures for ever. (Being) Greater for Australia is one of the Reasons why I don't sell My Paintings. The only Ones who get My Paintings is Adelaide Art Gallery or other Government Art Galleries. Art is one of our Great Tourists enjoyments.

And so My Lands of Fantasy Fantastic Art Galleries Joy World has outstanding Australian stories. My Little Wild Aussie Families, Wild Tribes are Real Australiana. My own Life in the Olden Days is somewhere in My Paintings. All woven into My Gifted Natural Lives.

IRIS FRAME
The Frightened Kangaroo, 1981–82
Oil on board, 61 x 46 cm
Collection: Riddoch Art Gallery
Photograph: Courtesy of the artist
and Riddoch Art Gallery

Annie Franklin

I think I have always wanted to create. Ever since I won a school poster competition at the age of seven, I have wanted to be an artist when I grow up. I still do. I spent a great deal of time drawing as a child particularly with my grandmother who was a very skilled painter, although she was given little encouragement nor opportunity. Any success I have in my own work I think means as much to her as it does to me.

I studied printmaking at college, although I now spend a lot more time teaching myself to paint. My approach to my work has always been that of a narrator, visualising stories of people, places, events and experiences, and it is this narrative approach where a sense of journey or place is suggested in a simple or abbreviated view, decorated with intricate details and vivid colour that has its links to naive/folk/grassroots art.

I think this approach to my images developed post-college when I was involved in community arts in Canberra on murals, book illustrations and posters. When working with a committee of people as I often did, it becomes important to develop the skill of discovering the essence of, or real story behind, a collection of opinions and visualising this in a strong and symbolic design. I look for the 'story' in everything; landscape, places and people; stories that are quirky and entertaining and stories that have some insight into a life, a culture, an issue that might make viewers stop for a minute, and think.

I think I must have some nomadic ancestry, I seem to have been born with itchy feet. Every corner of this country has its own particular beauty, its own stories and mystery. I have been able to travel fairly extensively across Australia, as far as my old bomb will take me, but I have seen only a fraction of what this land has to offer. Much of my work emphasises the intrinsic beauty of this land, its importance and its vulnerability in the hands of those with no respect.

Two years ago my journey brought me to this piece of paradise called Melville Island. I have been employed as an Arts and Crafts Coordinator for the Women's Art Centre; working with a group of young women who share with me an enthusiasm for

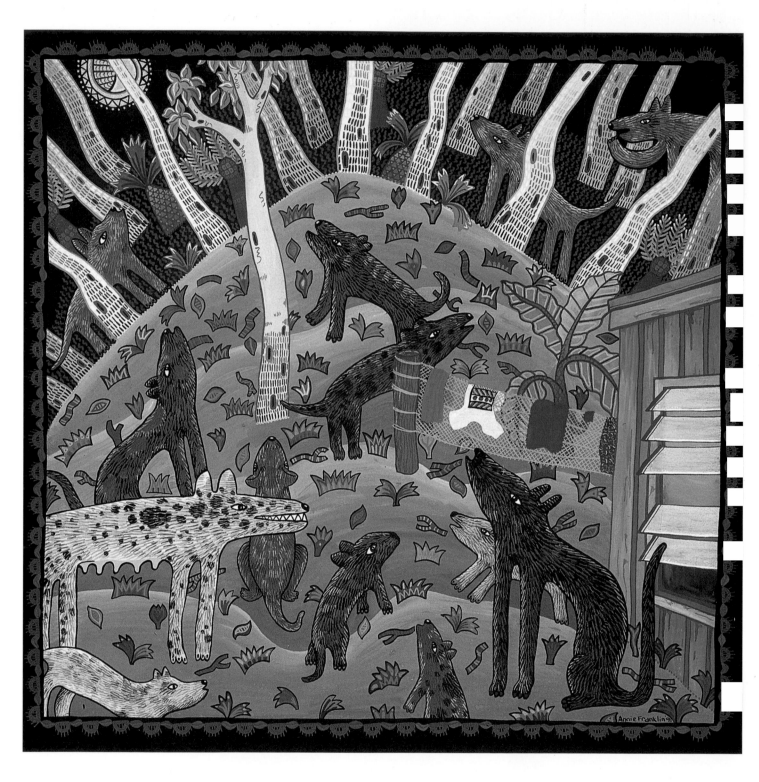

ANNIE FRANKLIN
Them Dingoes are causing Trouble again, 1991
Gouache on paper, 42 x 44 cm
Private collection
Photograph: Richard Pedvin

colour and decoration and for the beauty and spirituality of this land. My job is to share with these women new techniques and mediums and to teach them the administrative, management and business skills necessary to deal with the world of galleries, retail outlets, contracts and government funding assistance, a world far removed from their own. In return they teach me new ideas, new perspectives and share with me their warmth and laughter, their stories, their land, their lives.

Since living in Pularumpi my work has been an interpretation of this new and exciting country, a landscape that can be at once both harsh and formidable, sheltering such creatures as poisonous snakes, crocodiles and mapaditi spirits; and at the same time yielding delicious and colourful bush fruits and berries, an abundance of seafoods, life-giving crystal clear waterways, splendid prehistoric palms and abundant varieties of brilliantly coloured birds and insects.

The Tiwi islands are a very small and very unique part of the world and the Tiwi people and their stories are an intrinsic part of the beautiful country in which they live. Their stories are a simple and logical explanation of the way things were created and why, and have their basis in creative rather than scientific thinking. These stories bring alive the magic of the natural world and make it even more special.

The Tiwi people have adopted me as a family member and to these people kinship is very important. It is their close family relationships and their link with the tribal land that has kept their culture strong and, although there have been dramatic changes, it has survived against all odds of white invasion. To be a part, in my own way, of this family provides me with much needed strength and support when I am so far away from my own family.

To be given a little insight into another culture is a wonderful and rewarding experience. I hope that my images will at once entertain and enlighten the viewer.

Anne Gibson

Mum painted and she had lots of art books; I loved looking at them especially Toulouse-Lautrec with all the people in the theatre and the dark bits. So Mum painted and we just painted too and it was never anything that you wouldn't do. I mean, it wasn't an unusual thing to do.

I remember children would come over and we'd paint in the kitchen. Mum must have been giving them painting lessons. So we were surrounded by it all the time. You'd just do it. And I was good at it. I always did the best drawings at school, so I just kept doing it I s'pose.

I went to Sydney College of the Arts the first year it started at Balmain in 1977. But I had a teacher who was a conceptual artist. They don't do any painting basically, or what they do seemed really boring to me. You have to have ideas about everything all the time and everything has to mean something. I wanted to go there and paint. I had all these ideas about going there and painting and how much fun it would be and it just wasn't. One lecturer — I can't even remember what the subject was — really liked my drawings and that was all I wanted. Some encouragement. You do really good drawings when someone likes them. I don't think I even made it through the year. So that was art school.

Then I painted T-shirts and sold them at the market. That's why I think I might not fit into the naive category because I have done lots of different things. I did posters for our band, The Herd, and other people. Just from doing the T-shirts you end up doing other things … without meaning to, I got into doing I suppose graphic art — so I can do all that sort of thing too, but it is self-taught. Looking and seeing.

My subjects are usually what is around me at the time. I do change things, like I don't put in really hard bits, or I cut out things. Once I did a picture of the harbour or a room with a harbour view, but I couldn't be bothered doing all the buildings and the Harbour Bridge, so I just left them out. That's the fun thing about painting you can do whatever you want.

It's that feeling of discovery and when it works and you've done a picture you like. I

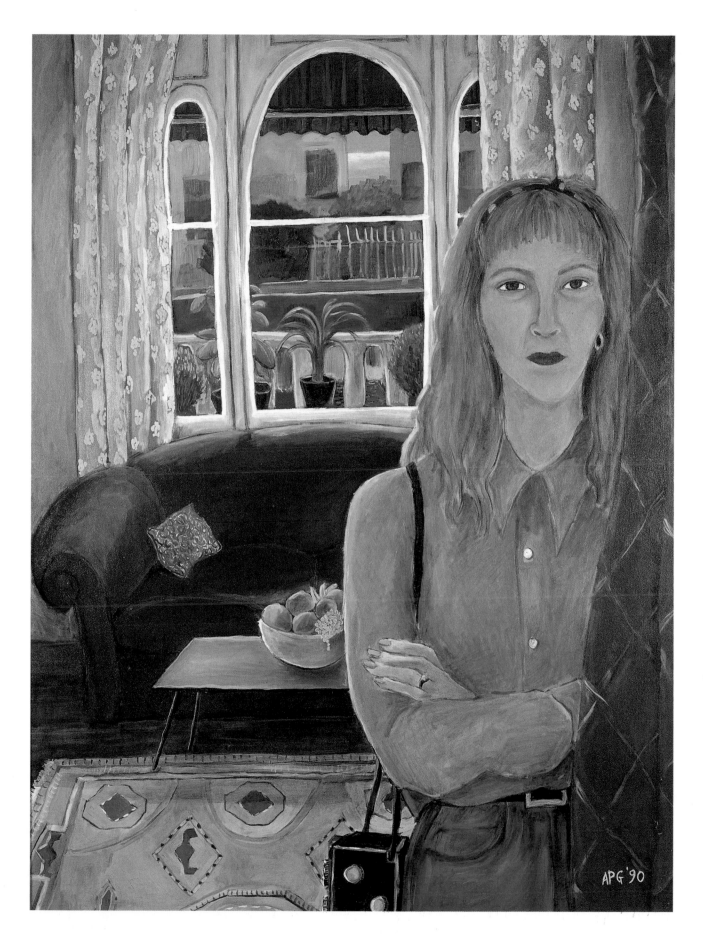

ANNE GIBSON
Portrait of Anne Zahalka, 1991
Oil on canvas, 100 x 75 cm
Collection of the artist
Photograph: Robert Walker

suppose that's what I enjoy about doing pictures. I like it when you look back and think, 'How did I do that?'

I like patterns. I did a picture for the Waverley Art Prize. You have to put in the form months before the painting has to go in; I knew I'd probably do an interior, so I put 'Interior' and sent it off. Then I had to do the picture. I painted the sitting room, but I called it The 'Living' Room, because by the time it was finished, everything looked like it was alive. That's when I like my pictures too — I go to it thinking I'll do it like it is, but it never ends up that way. They never end up looking exactly how they are; they always get weird angles on them and they get to be kind of alive in their own way.

So I'm really happy when I've done a picture like that. That's what my idea of success is. It's satisfying because you can look at your own work and really like it. That's a good feeling.

I did a manic self-portrait. It's really weird. I was very tortured one day and felt like doing a painting. I tried to do one but it was awful, so I scrubbed it out and did a self-portrait. That's one of my things — when in doubt, do a self-portrait. As it turned out, I liked it: it's like the Portrait of Dorian Gray — manic me. Nobody else likes it. My sister Emily put an axe next to it. Suits the picture perfectly.

I don't really know how to classify myself. I have a friend who's always busy trying to classify me. People just do their work. I'm a domestic artist: trying to make the best of it, the best of my little world.

I don't see a problem with things being appealing. It doesn't bother me not being in the 'Art World' because I'll do it anyway. I'm not going to not paint because I'm not in the 'Art World'. That's not the point. I don't know what the point is at all. It's like you can't *not* do it. You could compare it to some disease you might have. It's part of my life. I have to do it.

If I'm not doing drawings or paintings, then I have to be making jewels or something else that gives me the same feeling. Which is not cooking or cleaning or changing nappies or the washing. I don't do any of those things if I can possibly help it!

Marie Jonsson-Harrison

I am driven by a burning desire, almost uncontrollable, to paint, paint, paint. I work six day weeks normally 5 to 8 hour days although that can stretch into 16 hour days when deadlines come close. My dream is to change the world, make everybody happy, no need for crimes. hunger, illnesses and unkindness. I want to inspire people to smile and feel good and pass that happiness on. A lot of my work has an environmental message as that is something I care strongly for, especially animals.

My subject matter comes from everywhere, anything can spark me off. I currently have over 60 ideas as yet to paint and for evey one painting done I usually come up with another three ideas. I always listen to ABC radio when I work and they provide me with plenty of subject matter (sometimes I listen to booktapes, for example biographies of Papa Hemingway and Katherine Hepburn) as do my children and friends and parents — especially my dad who is a sculptor.

MARIE JONSSON-HARRISON
Sydney Aquarium, 1992
Acrylic on board, 50 x 25 cm
Private collection
Photograph: Michael Barnden

My husband Bryan is currently 'house-mum' which allows me so much time painting. My children Kai 5 and Hillivi 15 months are wonderful (from a biased mum) and I usually stop painting around 4 when Kai arrives home from school, when we will go for walks together, play and talk, have tea and a bath then spend time reading stories.

Generally I just do a very rough sketch and then paint the background straight away. I do not like to see any white colour showing through. I then cannot wait to fill in the space. I see the finished product all in my mind but cannot sketch what I see. I only achieve this with the colours. My paintings take quite a long time: the 10 x 8 take approximately 30 to 40 hours and the larger ones anything from 60 to 100 hours to complete. I cannot part with a painting unless it is just 'so', so any shorter time is impossible.

I'm very driven. I have to do things all the time. I just adore painting. It's not like working. It's a pleasure.

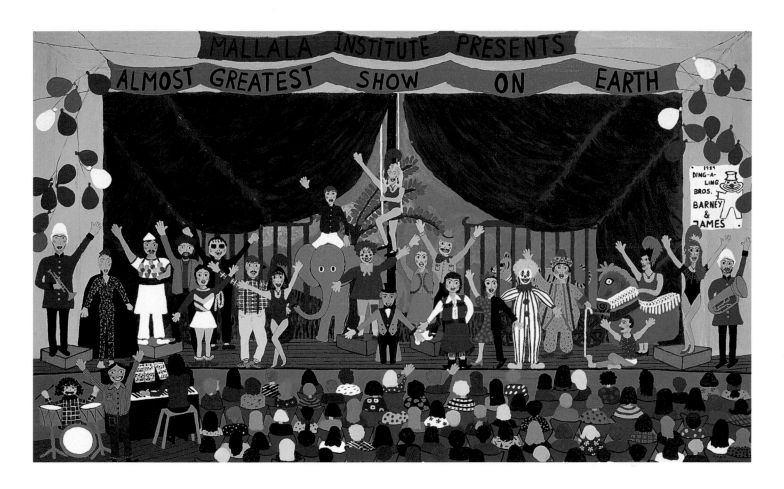

MARIE JONSSON-HARRISON
Everyone's a Star*, 1991*
Acrylic on board, 61 x 51 cm
Private Collection
Photograph: Michael Barnden

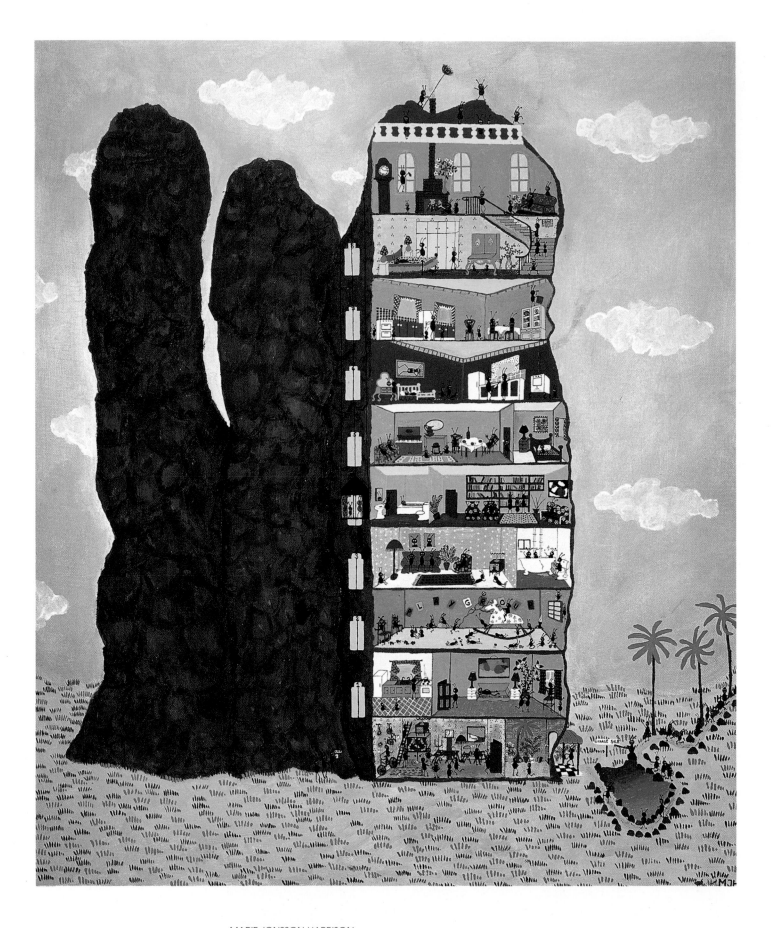

MARIE JONSSON-HARRISON
Anthill Condominiums in Katherine NT, 1988
Acrylic on board, 51 x 61 cm
Private collection
Photograph: Michael Barnden

Elfrun Lach

During an extended holiday in Australia I was offered an exhibition of my miniature paintings which I had brought from Germany. That first exhibition was very well received and encouraged me to take up painting full time. Ten years later, I am still living and working in Australia, trying to express my continuing fascination with this country and its customs.

As I paint mainly from memory, my paintings become a mixture of fantasy and reality. Imagined people in a real landscape or vice versa; half Australian, half European.

Sometime a surreal element appears to express dreams, such as people with wings flying through the air, or taking the shapes of giants or dwarfs.

It's the depiction of people I am most interested in. People in various situations in life, seemingly trivial but all-important, often humorous.

People relating with each other: women with men and, as I have come to appreciate in Australia, most importantly, men relating with their mates. This phenomenon alone will provide enough inspiration to last a lifetime, as I am only just beginning to understand its finer points.

My people generally appear well-rounded and middle-aged, an expression of personal protest, subconscious at first, but now quite deliberate, against our youth-adoring culture and a strongly-held belief that old age should be something to look forward to.

Being able to escape into a different world is an enjoyable benefit of my work. Painting in the bush when I tire of life in the city, idealised European villages when I get homesick or holidays in lush, tropical seclusion often have a therapeutic effect.

These are short excursions, though, as in a perfect world there would be nothing to laugh about. Accepting human weakness as part of what makes life worth living is what I want to point out. Being able to do that while putting a smile on people's faces is the greatest reward.

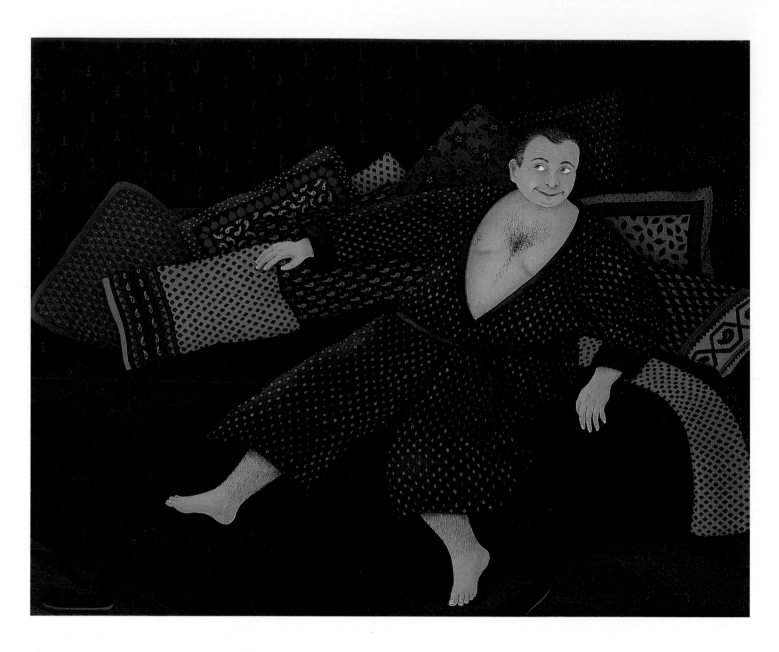

ELFRUN LACH
How about it?, 1990
Acrylic on canvas, 20 x 25 cm
Private collection
Photograph: Craig Beard

Kevin Lane

Storytelling is very important in Australian culture — the yarn around the campfire or lounge room or bar — and my work is an extension of that. I grew up on stories — before TV — and when we went for holidays we spent all our time telling each other stories. Then we had uncles who would come down from the city, so I heard stories about the inner city, the gangsters, the whole works there.

I was born in Bega. Then we moved from Bega to Jindabyne, Jindabyne to Gunning, Gunning to Nyngan, Nyngan to Gilgandra. Gilgandra to Gundagai.

My Dad was a headmaster. In one way it was good because I collected bits and pieces from almost everywhere. I guess that's been my life since then too, although now I think the longest period of time I've been anywhere is in Sweden: 13 years. I spent 10 years working and travelling in Papua New Guinea before that. I'm married to a Swede and we tried to come to Australia but I think being a Swedish woman with a career (she's a psychologist) it's rather difficult for her to settle down here. But for me it didn't really matter because I need somewhere very quiet to work. I go back to Sweden and work like mad: everything I want to do is inside me so I don't really need to be in Australia working. I find it very easy to work in Sweden. Funnily enough, it's very warm because we have a very good, insulated workshop and the wood is there. I work only in wood. That's partly because I trained in the monastery and we painted a lot on wood.

When I went to the monastery we were encouraged very strongly to paint. We had the Procession every year and we painted big banners to put up. It was a very strict Redemptor Monastery in Galong. I painted the icon of Our Lady of Perpetual Help about sixty times! But it was a good discipline because we traced onto the wood and that's the technique I use now. I draw mirror images, trace it off and put it down onto wood. Then paint and lacquer everything.

I guess my subjects come from the stories I heard when I was a kid. A lot of stories from the Bible which I thought was so much fun. We used to read all the martyrology which was very exciting: they had the most atrocious things done to them. Trying to be devout Catholics, we weren't allowed to laugh at them but inside we all laughed! There was a bit of a silliness about the whole thing: as somebody said,

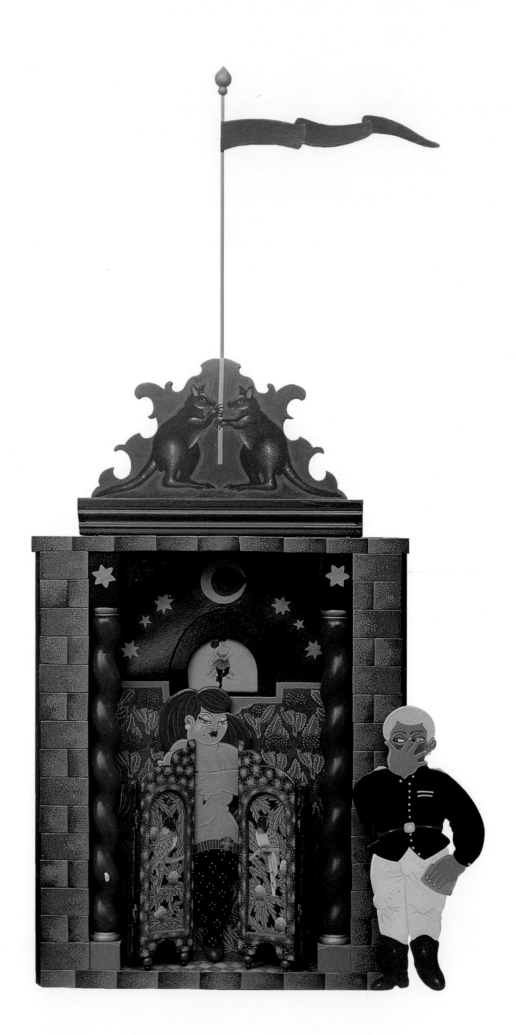

KEVIN LANE
**Bailiff Brown Attempts to
Arrest Lola Montez**, *1989*
Lacquered gouache on wood
133 x 55 x 10 cm
Private collection
Photograph: Robert Walker

there's no sense in having God if you can't laugh. I know the nuns in Sweden have seen my stuff and laughed. And brought their friends the other nuns back when it was quieter so they wouldn't be seen laughing. They weren't shocked at all!

That's one thing that I'm definitely not out to do — to shock. I'm just out to have a bit of fun. And serious fun. It's not as though it's all off the top of my head.

Most of my subjects tell the stories of those bits of Australian history that we don't really know, and I think Australians would like to know more about. I want to take a direction nobody else has ever covered — colourful characters like Kate Leigh.

I just love Kate Leigh. My parents were great fans of Kate Leigh. She was the arch enemy of Tilly Devine and my family were Irish, so Kate Leigh was their champion. She was from Dubbo — a country girl who'd made it big. She was a big, big woman with huge hats. She had a heart of gold. She used to walk around with a big black bag and if anyone was short of a few quid, she'd give them money; she'd bail them out. If she saw a young girl working on the street, she'd hit her and say, 'Git off the street yer silly mug!' She hated coppers but she had a lot of respect for Lilian Armfield, Australia's first policewoman. She would never swear at a woman, not a 'real' woman: somebody rough or a bloke. She even shot a bloke once. She was Surry Hills. Tilly Devine was Darlinghurst. They were the two main women.

This is something I haven't seen so much in other countries: women running the crime. I've heard there are even tougher customers. There's a woman from Hobart who ran a pub down there — she could throw out three men at a time!

And you see our family being Irish, you've got lots of police in the family. We've got three cousins in the police. They don't mind giving me a few stories on the side as long as no names are mentioned.

So that's why I do social history and for me its much more exciting. When I did the Bible, I did mostly Old Testament stories. I'm not that interested in illustrating the New Testament since that's 'religion' and it's not my intention to proselytise.

I was picking the women out of the Bible, the story of Tamar I just love. I like those stories because they're not so well-known; they haven't been done to death. And they have these very strong women.

I want my stories to be understood. It would be very sad if it were like going down to the cellar and singing to myself. So I really want to get my pictures and stories out. My kids are growing up and I tell them stories all the time and they nag me to death: 'Tell me again'. So I'm always looking for new ones. Australia's a real storytelling country. It's the Irish tradition, it's the bush tradition and I guess that's an extension of where my heart is. That's why I don't even bother to exhibit any more in Sweden. I can exhibit in 4 or 5 galleries in Sweden, the Swedes like my stuff. But I'd rather come out to Australia and tell them my stories. I feel they're Australian babies.

I like dreamy-eyed ladies. There are a lot of them. I find them on buses; I find them all over the place. They are all people I've seen.

I've started to do a bit of everything. I've started to paint the frames. Now I make everything: I did a course for a year in joinery. So now I make all the frames myself. I have much more control over it and it's less expensive.

I'm starting to use a board that I learnt to use on the joinery course which is so good for carving. One of the things I want to do is make them even more complicated but put them behind perspex and make them like the Australian Museum objects. I've been four times to the Museum since I've been here this time. I'm working on a thing with bush food and making collections of moths and butterflies, beetles and lizards and putting them behind perspex so that they look like what I saw at the Museum.

Frané Lessac

I've painted since I was two. Because my lines were never straight and my paintings had no dimension, my schoolteachers told me they were wrong. I would have to climb into the art room window after school to change my grade in the professor's book.

My father has a great appreciation of natural light and colour. He would point out to me exceptional objects or scenery or people, unusual phenomena, beauty. I think he enriched my visual outlook.

I grew up in a small town outside of New York City. From my bedroom window I could see the famous skyscraper skyline. I had a lot of freedom as a child. (At 8 years old she was a beatnik, seen hanging around Greenwich Village with an orange-tongued green snake entwining her arm.)

I studied film at the University of California, Los Angeles. I wanted to make films about 'primitive' tribes before they were swamped by western culture. I lived in a beachhouse in Malibu alongside movie stars. Actually lived on their discarded furniture: we had Flip Wilson's lawn chairs and Barbra Streisand's settee. I worked a lot of part-time jobs to finance my studies, from projectionist at the local Malibu cinema, to fertilising cactus with a silver spoon, to chauffeuring a woman with a broken leg around Beverly Hills.

Then I spent 5 years on the Caribbean Island of Montserrat where I found it a great relief to stop carrying cameras and lenses. I began painting the scenery, flora and fauna, architecture and peoples on the small island. It was only 7 by 5 miles. Tourists and visiting rock musicians began to buy my work.

I wanted to publish a book of my paintings, so I moved to London where I lived for seven years; also much of the time in Paris. I approached 30 publishers before one agreed. Meanwhile, I had a great time working as a personal assistant for a member of a popular rock band and got to travel throughout Europe in limousines and helicopters.

I met my Australian-born husband, a musician, in Bali where he was running a club and I was filming a documentary on Balinese painters. We moved to Fremantle

FRANÉ LESSAC
Red Road, 1992
Oil on canvas, 110 x 56 cm
Private collection

several years ago, where we now live with our two small children, a cat and some goldfish.

I work in two mediums: oils and gouache. The gouache paintings tend to be more detailed and I work flat on a table. The oils are painted quite large on an easel.

I have at least one exhibition a year and finish one or two books. I've painted the pictures in all the books and have written three of them myself.

I find the Australian landscape a brand new challenge. What inspires me is the freshness of the scenery. I'm dazzled by it. The red ochre of the earth, the uniquely blue Australian sky, the people prawn fishing on a river or the girls outside a brothel in Kalgoorlie. They're all new pictures for me.

Bob Marchant

My wife, Inger and I drove up to Ayers Rock in summer 1992 and on the road on the way up there, especially when you get up around the Broken Hill area where there hasn't been any rain for 2 or 3 years, we saw absolutely millions of dead kangaroos on the side of the road. Each night, they would come to the road to drink the condensation. Within a hundred miles, we counted 300 on the road into Broken Hill. The Wedge-tailed eagles would come in at dawn and make off with the carcasses. They are the best-fed birds in Australia — they live off fresh kangaroo every morning.

The Wedge-tailed eagles are beautiful birds and I've always wanted to paint one. I didn't want to show him eating a kangaroo because everybody loves kangaroos, so I put a rabbit in his talons.

The Wedge-tailed Eagle is flying over Mount Conner. As you drive up to Ayers Rock, you get to about 150 miles off it and suddenly you come across this massive rock which you can see for at least 100 miles away. You think it's Ayers Rock but as you get closer and closer, you realise it isn't Ayers Rock: but it's more impressive than Ayers Rock. It's bigger and higher.

Mt Conner is on a farmer's property and he rarely lets people go out there. He's got a gate up and you've got to get a special key to go out there. He gave us the key and we went off one day and we climbed all over the back of the mountain and there were all these Wedge-tailed eagles flying around.

When we went back to the farmer's house, I saw a poem pinned on the wall that was written by an eight-year-old girl who had visited the place. She wrote about the place 'where the eagles nest'. It was a beautiful poem of about 20 or 30 lines, one of the most moving poems I've ever read. I said, 'When I do Mt Conner, I'll do it with the Wedge-tailed eagle and I'll call it *Where the Wedge-tailed Eagles Nest* after this poem by this fledgling Henry Lawson.'

I went over to England in 1960. I was there for a few years when I started to develop a great love of art: I was mixing with a lot of painters, good Australian painters like

BOB MARCHANT
Where the Wedge-tailed Eagles Nest, *1992*
Oil on canvas, 100 x 100 cm
Private collection
Photograph: Billy Wrencher

Brett Whiteley and others who were selling their paintings for thousands of dollars and the only ones I could afford were the Naives. So at the age of 25 I made this major decision in my life that I would go out and buy an original painting every year as my birthday celebration painting and I hang it on the wall. If you look around my home, these paintings represent each year of my life. I've been buying paintings now for 25 years, so if I live to be 100, I'll have 75 paintings!

My first exhibition that was organised in any way was at Ken Done's big gallery in 1988 — quite by accident. I'd been painting for 10 years: I'd probably done about 30 or 40 paintings. A lot of people had seen my pictures and said they should hang up in a gallery but I said 'No, I just paint for my own pleasure'.

Then I was coming up to my 50th birthday and thought I'd like to have a big celebration. Ken Done had said to me that he had this enormous place that he was at that time just using for his own work and he said, 'All your paintings are very large. If you want to hang them up there just give me a call'. I suddenly got this idea that if I hung up all my work in his gallery, and invited along friends, we could all have a drink and a laugh and a joke and look at some paintings and go out for dinner and that would be the best way I could think of to celebrate my birthday. What happened was that, apart from having a wonderful birthday party, I sold all the paintings.

How did I come to start painting? Well, I met this marvellous Indian man, Nevil Singh, in London one day when I was walking in the street. It was pouring with rain and I was trying to get out of the cold and wet — a grey, dismal, typical English day and I was running to a pub where I knew there'd be a fire and a warm drink. All of a sudden I heard a song coming out of the sky: 'All Things Bright and Beautiful' and I looked up and saw this Indian man sitting on top of a roof. He had a black umbrella up and he was painting a sign on a hardware store. He was just sitting up there with his paintbrush and his paints, singing this song.

I stopped and said, 'I'm freezing to death and you're up there so cheerful! You've got to be the most optimistic man in the world!' He said, 'I'm a painter I don't care whether its cold, hot, steaming — everything around me that I look at is beautiful. I love the sky when it's grey and has rain coming out of it, I don't mind when it snows, I love it when the sun comes out and the flowers start blooming. I only have to look at a tree and I feel good, I look at the grass and I feel great. Everything around me is beautiful, because I'm an artist. What do you do?'

I said 'I'm just heading off to the pub to have a drink and you're a very interesting man, I'd like to get to know you,' and we went off and had a talk and became lifelong friends. I got him to come and stay at my home where he painted my bathroom: he painted the four seasons. We had covered our whole bathroom in mirror and he had this beautiful technique where he could paint on mirrored glass. I used to sit in my bathroom and because each mirror would reflect into each other, I could see for about a million miles down the bathroom. People used to come from all over London and say that it was better than going to Buckingham Palace or Madame Tussaud's or the Tower of London!

When I told him I was leaving England to come back to Australia, he asked me what I was going to do. I told him that I was going off to a Greek island for a year to have a rest and decide what I wanted to do for the rest of my life. He said, 'I bought you four tubes of paint and two brushes and if you get tired of drinking retsina and eating fish and swimming in the sea and lying on the beach, try painting.' I said that I wouldn't have time to paint, I'll be too busy thinking about a novel I want to write.

As it turned out, after six months I decided it was going to be very difficult to write this book. I was running around the island photographing and doing lots of other things, when one day I saw a beautiful cloud in the sky: it was wonderful — just nestling over an island. I thought, will I photograph it? Will I write about it? Then I thought, No! I'll paint it! So I rushed in, got the paints, got a piece of board that was lying around the house and did a little painting.

Everybody on the island came to see my painting and they all squabbled and argued and said they wanted to hang it up in their house! I got such a rush of enthusiasm to have done something that everyone was fighting over and loved and wanted me to give it to them that I thought, if you can get this amount of satisfaction out of doing one picture, I should be doing more of this. So I forgot about photography and writing books and since then I've concentrated on painting. And that's how I started. I was 40 years of age when I reached that decision, so I didn't rush into it!

I couldn't not paint now. It would be impossible.

I've got a theory about this whole thing, because I'm starting to look back now: once you've been on this earth for 50 years, you have a chance to look back and figure out how I ever got involved with painting. Did I ever make any decisions along

the way to do it? Every time I ask myself that question I realise I didn't. What I believe is that all of us are put on this earth for a reason and it takes some of us a long time to realise why we're here. I believe that there are people — I don't know what they are — gods or spirits who help and guide you. They could be 'spiritual guides'. I believe now that I was put on this earth to paint.

I was born in this country town where there was no 'culture' — most of them were farmers. Growing up in that area there was no artistic encouragement at all. Our home was completely bereft of pictures or books.

I think I was sent over to England to learn how business, the world and civilisation operates, and once I'd learnt these lessons I could then return to Australia and paint. I didn't make any decisions. I had to go through at least 40 years of my life learning how to deal with business because being a painter is a very difficult existence. Commercially, most painters, however talented, are failures. I wasn't going to be a starving painter. I consider myself to be very lucky that I had such successful shows when I first began.

I grew up in what is probably the archetypical Aussie bush town a million miles from anywhere. Then I was transported over to England where I got involved in the Swinging Sixties, in one of the most cultural cities in the world. When I came back to Australia, I started looking at it. I didn't know what the rest of Australia was like when I was growing up in Dimboola — it was the only place I knew. But once I'd gone to England and America and travelled all over Europe and came back, I thought I was lucky to be born in the country because we are very unique people in this country and Dimboola reflects a lot of it. So I know a lot about Australia that people who have lived in Sydney and Melbourne and other cities don't know.

I can go into the bush and feel it's my backyard. I feel quite comfortable in the city and I don't know whether I could ever go back to the country. However, it was very good to have spent the first fifteen years of my life growing up in a small country town and that's something that as an artist I keep drawing on.

I never trained in colour — that's just something that was God-given. People often ask me how I get my colours to work and I say, well I just put them down. They say, but some colours don't work and I say I've never found any that don't work.

BOB MARCHANT
A Sacred Place, 1992
Oil on canvas, 100 x 100 cm
Private collection
Photograph: Billy Wrencher

I often put amusing titles on my work because I like to entertain. I think painters are entertainers. I'd much rather do something that was a bit of fun, that people can get a bit of joy and pleasure out of, than something that is dark and deep and mysterious that nobody understands.

A Sacred Place: This is an Aboriginal sacred site. You have to get a special licence to go out there because they've reclaimed all the land now and they're not letting white guys in. I got a permit and went out and camped on their land. There were so many beautiful sacred sites around there, large billabongs with waterfalls running into them. It was probably the most peaceful place I've ever been in my life. So that painting's very special: it reminds me of a very good week just camping and fishing in amongst all the birds and animals.

I follow themes. I did a series of pictures featuring my wife Inger which are all about discovering the outback of Australia through the eyes of somebody who wasn't born here. I find that very interesting to paint. Next, I'm going to do a whole series about Cooberpedy and the people I met out there: they all live underground. I'm going to paint their homes, I'm going to paint them working, I'm going to paint their fantasies and their love affairs. The opal represents The Dream: everybody there is chasing The Dream and for every thousand people who go out there with a dream, only two or three ever find it. It's the worst place to live, the temperature gets up to 45 degrees (Celsius) in the summer. The only place you can feel comfortable is underground. There are no trees just all these white hills where people have been burrowing underground like rabbits. It's a weird place. You've got to be a bit mad to live there.

Denis Meagher

I used to do cartooning for fun, but I actually got painting to impress
Etienne at the Australian Naive Gallery.

The first picture I ever did was a picture of people in a pub. It took something like three months to do. And then the next one took about a week. They both sold straight away! Went into the gallery on a Saturday and sold on Sunday! So that gave me the confidence to keep going.

The furniture is stuff we found. I don't specifically go and look for certain things unless somebody's asked for something specific. Otherwise, its just what turns up.

The *Circus Desk* was the first thing I did. I was inspired to do it to set a trap for a guy I know who has a whole circus of tin toys: all the things that he likes are in it. I wanted to have that whole look of tin toy type colours.

I think Kevin Lane inspired me to paint furniture because of his pieces. Not that they're actually furniture, but they're multi-dimensional like furniture.

Also, fixing up my house and working for John Normyle — he wanted a few things restored and painted. That's how John Venerosa and I learned techniques of shellacking and how you do antique pieces of furniture. I think this is why we have quite an advantage over most people who paint furniture. They don't really have good finishes to put on them and they don't try to make what's painted on go with the piece, whereas if you're shellacking it, and waxing it and putting black japan on it, it makes it part of the piece. Also, we learnt a lot about repairing furniture.

I paint whatever seems appropriate to the piece of furniture. Except for my obsession with lorikeets which went on for a while. Etienne bought me a book on Australian birds and I got stuck on the rainbow lorikeets. Although I've done a few rosellas. There are so many rainbow lorikeets around here, around Glebe. They're amazing birds !

DENIS MEAGHER
Circus Desk, *1991*
106 x 77 x 40 cm
Private collection
Photograph: Robert Walker

Painting and painting furniture are the same thing for me, really. I've started to paint more on things. More like paintings on things than painted furniture.

The really nice thing about naive art is that I had a 30 year break from painting and was able to come straight back in to where I'd left off when I was 10. I was really into painting when I was little up until about 9 or 10. I used to paint holy pictures because I was a holy little Catholic boy. Then I went to a school where they didn't do art. They thought it was stupid.

The best thing about it is that I didn't paint all through those terrible years when I was a Serious Young Insect. There's no way I'd be painting by now! If I'd gone to a school where they had art, I might have gone on to art school and probably hate the whole concept by now but know a lot to say about it.

Before I started doing this I didn't even go to art galleries, because I didn't understand. I'd see all this stuff on the walls and I'd just have to nod my head when people said it was good and say, 'Oh yeah! I like the colour', or some bullshit like that. I had no idea. It's all very intimidating. That's what's nice about naive art — it's not.

When we were living in Amsterdam, I was given a book on American Folk Art and this inspired my first 'naive' pictures. It was like going back to the basics. Someone told me it was 'naive'.

I just paint for myself, what I want to do, not what other people want me to paint, and I'm really enjoying it. Of course when it sells, that's even nicer!

My paintings usually have a story to tell. I might look at something that triggers a memory or see or read something and make a scribble on a piece of paper and put it in the 'possible painting box'. *Looking for the Stitches* has a story to tell.

I heard somewhere the story of the arrival of the first platypus in England. It seems he was examined very closely because they suspected that the platypus had been put together from different sections of other animals. That is why it is called *Looking for the Stitches*.

In this painting there is also a reference being made to the Aboriginal story of how the platypus came into existence: the story of the rat and the duck. There was this family of ducks swimming around somewhere and one of the little ducks goes walkabout and bumps into this rat. The little duck is captured by the rat and he takes it home to his nest. Out of this 'relationship' the platypus is born.

In the picture, the man on the left is holding a duck, and the man next to him is holding a rat by its tail. Which is sort of holding the Aboriginal story in the painting.

What I really like about the way I'm painting now is that I don't paint the way it has to be, I can paint the way I remember, the way I think it is. It gives me a bit of freedom. The platypus for example should be in reality, you know, smaller. But I just felt it should be a great big fat platypus. Until I had seen one in real life, I expected the platypus to be much larger anyway.

What was a challenge to me was trying to imagine the scene — the light (I wanted to get that golden antique light), the different thoughts of the scientists on 'the platypus matter' and then paint it.

LOTJE MEYER
Looking for the Stitches, *1991*
Oil on linen, 111 x 97 cm
Private collection

Miriam Naughton

I'd never painted before but I had this urge, an obsessive thing, but I never had any opportunity to develop It. On Yarrabah I did, because the old Aboriginal fellow taught me how to paint. So the new bishop came on a visit, Bishop Belcher, and it was going to be a great day, a big hoo-ha, and all the children from the boys dormitory and the girls dormitory down on the foreshores and Father Brown there in his cassock and Sister Stanley in her grey uniform and our dear old accountant. They're all dead now. Makes me feel old.

Anyway, the bishop came ashore from the boat, *The Careel*, sitting out in the Harbour and all the people are singing, 'The Church is one foundation, as Jesus Christ Our Lord'. While this is going on, they'd started a corroboree up at the back of the village and you can see the people starting to run from the edge of the crowd, racing up to the marvellous corroboree. The bishop wasn't too happy about all those painted, semi-naked people. But the older people had their way, and their way of celebrating his visit was to put on a corroboree.

MIRIAM NAUGHTON
The First Visit of the New Bishop
to Yarrabah, *1947*
Oil on canvas, 90 x 100 cm
Collection: S & S Dickson
Photograph: Robert Walker

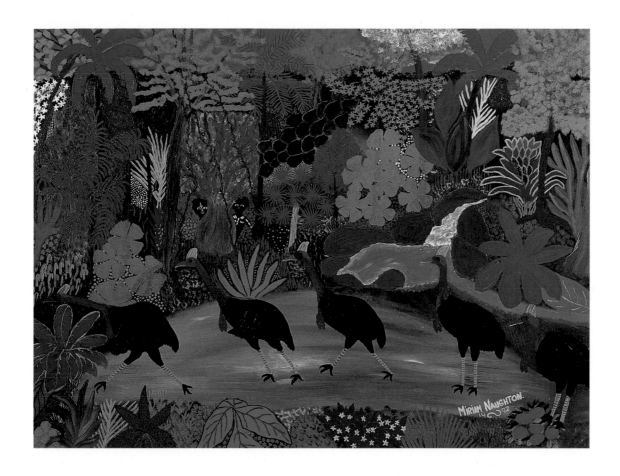

MIRIAM NAUGHTON
Cassowaries in the Rainforest near Cairns, *1992*
Oil on canvas, 82 x 110 cm
Private collection
Photograph: Robert Walker

MIRIAM NAUGHTON
Coral Gardens on the Barrier Reef, *1992*
Oil on canvas, 82 x 110 cm
Collection of the artist
Photograph: Robert Walker

It's all gone now, but I've put in the little thatched church. It had a banner which ran right the way along on the inside of the church, but I put it on the outside. It says, 'Lift Up Thy Prayer for The Remnant That is Left'. Very apt.

It was the first painting I ever did and d'you know, it kicked around for years, rolled up, then in a frame then rolled up again and it ended up in the fowl pens at Southill, our property out near Goulburn. They were huge fowl pens, heritage listed now. Anyway I used to use them to jam old stuff in. It was in there for a long time. I think it was chewed on at some stage by possums. Eventually, I was going to throw it out, but the Dicksons came to visit and they liked it and begged me to give it to them and took it home and framed it with great delight. When I saw it in the frame, I thought I'd better make it look respectable, so where paint had come off I dabbed a bit on it and now it's the pride of their collection.

It's historically important now, because all the missionaries who were there, most of them are dead. And the mission has gone too. It was a government settlement and now the Aboriginal people up there own it, so I think that painting should have been kept in that area, or in Cairns to show what it was like there just after the Second World War.

Coral Gardens on the Barrier Reef, 1992. I had never painted coral and when I was living up at Trinity Beach I saw the Reef from the point of view of my age now. When I was younger it didn't mean much to me. Now I find myself much more interested in things like reefs and animals and the environment.

So I decided that I was going to do my Reef, but I wanted to do it in a way that I could bring the coral forward because I wanted to show that the Reef is sharp, you see. So I pulled out quite a lot of coral at the bottom so that it all came out like little pinpoints. Took me months to do. Now I find it so sharp nobody dares touch it! I put lots and lots of colour in there and a big smiling shark and a turtle and all the fish that I see up there. I had a lot of fun doing that painting.

I don't know what 'naive' means. Bear in mind that I left school when I was 13 so I really haven't had any education. To me it was a way of expressing what was inside me that I wanted to bring out and I had no other way of bringing it out. It was my life and what was going on in my head; it wasn't what I saw, it was what I knew. What I knew and what I had seen in my life. It made me feel that it wasn't all for nothing that I could bring out some beauty in that terribly hard life Depression children had.

MIRIAM NAUGHTON
Self Portrait with Mother 1929, *1990*
Oil on canvas, 90 x 60 cm
Collection of the artist
Photograph: Robert Walker

MIRIAM NAUGHTON
**Uncle Alfred's New
Car 1912**, *1990*
Oil on canvas, 74 x 121 cm
Collection of the artist
Photograph: Robert Walker

We couldn't reach our full potential because we left school very early, we worked hard and then we had a war and we all went off to that. Afterwards, what did we do? We raised big families in those days.

We work through our obsessions our own ways without much knowledge there to guide us. You gain so much for yourself when you start painting and you find suddenly there's all this wonderful colour there that you can work with. It doesn't matter if it's an obsession, because it's a harmless obsession.

The first thing I knew some people had come down from Sydney to visit in their MG and said, 'Miriam, where are all those paintings of yours?' And I said, 'Oh, those things — they're behind wardrobes and in the chook sheds. Do you want to have a look at some?'. So I pulled them out, covered in dust and they were jumping up and down with joy and this puzzled me because here I had been sitting all these years and nobody ever told me what kind of art I did. I filled their MG with paintings. What had happened was that naive art had become popular.

I think about painting all the time. I must have a hundred paintings waiting in my head. Just waiting, like little babies to be born and in their own time, they're going to be born — all of them.

I usually put my signature in first. Because if I don't, I don't leave room for it. So I put it there and work around it. Then at the end I put a little coat over it because naturally the first coat is not very bright. When that second coat goes on and I sit back and look at it, the feeling of joy that comes over me! I say to myself I love that! I think every painting I do is the most wonderful painting in the whole world! And that it's my best painting! Every time!

Malcolm Otton

When I first landed in Australia, in the first week, I went down to Bega where there was a colony of relations of mine. I sat down with two venerable old ladies at the old homestead of theirs called 'Numerella'. Two Otton brothers had come out back in the 1820s or '30s and bought land there. So I went down and saw them and it was then that I started looking at the genealogical tree and found that I am really as much Australian as I am English.

By that time, I was absolutely hooked on the place. Before that, as a child in England, different cousins would come over from Australia bringing sheepskins and boomerangs. So I knew about it and felt it was a good place to come.

I spent some pretty rough years farming on the Central Coast. I had land up the back along a narrow valley called the Little Jilliby Valley, based on the Jilliby Creek. There was bush up either side of the valley with tracks leading in. Some of these tracks were just footpaths made by the timbergetters, but the real tracks were made by the bullockies. These were quite wide — two cars could pass at a pinch — but they were just dust tracks, pretty corrugated and lumpy.

Every two or three days, a bullocky called Bill Goldsmith would come jingle-jangling up the hill from the creek. I could hear him coming because the sleeper bridge over the creek rattled. You could even hear the bullocks' hooves at times. They'd go right up the back into the bush, with old Bill cracking his whip and screaming in the most violent, lurid language. He was a very big potbellied man with ginger hair. He'd give us a wave and sometimes pull up and have a yarn about things. We used to see him at the pub in town once in a while. Great old boozer. He always stuck in my memory.

That was the first subject I'd always wanted to paint. I took a very limited number of photographs up there during the War years with a very small camera. They were pretty rough pictures, but I wrote a diary now and then through those years. Also, I wrote a lot of letters to an old friend who had moved to Canada. I wrote to her right through the War. Years afterwards, she returned a bundle of them to me. They described raging bushfires and dust storms that blotted out the coast: my cousins in New Zealand told me they were getting rained on in Wellington by Australian dust. Right across the Tasman!

Washing Day is one in a series I started years ago. I'd been very much affected back in the early 1950s by visiting Hermannsburg with Charles Mountford, the anthropologist, who was doing a series of films about Aboriginal life for what was then called the Commonwealth Film Unit. I had been working at the Unit in the cutting-room as Mountford's Editing Assistant and running and re-running his footage of tribal rituals and secret ceremonies and desert life in general. It was a tremendous revelation to me — the starkness and the dignity of the nomadic lifestyle, the complexity and visual beauty of their ceremonies ...

Hermannsburg was the site of an Aboriginal Mission in the Macdonnell Ranges about 80 kilometres south-west from Alice Springs.

When I had the opportunity to visit Hermannsburg with Mountford I got a violent culture shock. Instead of the Initiation Ceremony, I saw the Washing-Day Ceremony. What a cruel, tragic downfall for an austere, age-old culture!

Anyway, about seven or eight years ago the Australian National Gallery approached Film Australia to make a film about Aboriginal children's art. In the course of discussions with Terence Measham who was in charge of the educational film end of things at the Gallery, I was handed a bunch of photographs of Hermannsburg and life going on there. There was one particular picture which attracted me by its composition and I thought I'd try it out as a painting. I did a pastel sketch which a couple of people seemed to like and I finally ended up turning it into a painting called *Ration Time* — Aboriginal people standing around with plates and mugs and bags of flour. That went into my first exhibition.

Over the last four or five years I've painted something like fifteen pictures centring around various Mission 'ceremonies': *The Wedding, The Doctor's Visit, Palm Sunday, Ration Time* and so on ... I guess the Washing Day ceremony is probably the most cheerful of them, but that's because washing on the line is always an attractive theme for an artist — the swirls of movement and the splashes and clashes of colour you get on a windy day!

My paintings aren't exactly documentary but I think all the painting I do ... well, I did forty odd years of filming documentaries, thinking in terms of making the world look the way it really is. You hope that some sort of truth comes through, that I'm telling people about the way life used to be.

MALCOLM OTTON
Washing Day, 1992
Acrylic on canvas, 50 x 90 cm
Collection of the artist
Photograph: Robert Walker

Maitreyi Ray

My island in the sun is a densely populated paradise. Every hillside is thickly peppered with thatched or tin-roofed shacks. There are barefooted grand-mothers in full skirts and bandannas and swaying high-heeled girls in tight dresses. Businessmen in spectacles jostle with dusty handcart vendors and peasants carrying bundles on their heads. Odours thicken the air burning charcoal, coconut husks, fat, franjipani and fish. This is my mythical home. It has all the elements I need for a rich life.

Living in Australia, everything is so new and pristine. When I go to India I am quite charmed by how nothing is ever wasted. A car tyre, for instance, will be patched and patched and patched and then finally turned into soles for your shoes. Nothing gets discarded.

I tend to pick up garbage. One night, driving around this fairly prosperous suburb, I found the makings of a whole show. I found three doors, six window frames, lots of really nice timber and tin, which are basically the materials I use. I bring them home and fix them up. I like the idea of giving them another life. I'm not into renovating or fixing it back to its original state, but in giving them another life, another dimension, a reincarnation.

I'm very deliberately a naive artist. I think what I paint is fairly childlike and I think it is developing into a technique because I have been doing it now for nearly 25 years. I think that if I spent three years at art school learning to draw a hand I might lose something. I might get sidetracked into technique rather than content. It's more the poetry in the art that I'm interested in. I don't really want someone to come up and look at my brushstrokes.

I don't put myself or see myself on any competitive level at all in the art world. I don't really care what my status is. I just paint what I paint and there are enough people who seem to like it to make it worthwhile for me.

I'm perfectly aware that my art is something that anyone who was into more formal art would not like. I imagine they would die of horror if they saw my technique and the primary colours I use! I know it isn't everybody's cup of tea, but I can accept that.

MAITREYI RAY
Ma Caille des Fleurs, 1991
Acrylic on board, 120 x 92 cm
Private collection
Photograph: Robert Walker

Geoffrey Rayner

My 'studio'? I call it my Iron Lung. Or The Snake Gully Tea Rooms, Nursing Home, Protective Care Unit for Tired and Old Pre Nuptial Plumbers. A bit of plumbing humour!

I'm not interested in selling to the public; I just do it for myself. The thing is, if anyone come along and asked me for something, I'd say take it! Leave me alone! Take it, take it!. I'm just that way. But I've had to quieten down. I found out I'd have nothing! Geez, what you can do! I've got no minder you see. The father passed away. I knocked off work and nursed my father for three and a half years. I've never, ever regretted it, so I've got no regrets in my life.

My partner left me this place. I'd come to him on a weekend in 1941. We were going down to make tanks for the Main Roads Board: twenty-nine two thousand gallon tanks up here at the Yass quarry and the rest were at Tumbalong in Gundagai. When I came back from the War, this man give me a bed and lodgings. He never got married either and I said, 'Well, I'll see it through to the end with you too. Even if I get married, you'll always have a home to come to.'

It didn't work out that way and when he passed on I thought the Presbyterian Church will do alright here. Gee, when you read the will, it was a different story: I got a hell of a shock! He left me pretty well everything.

In 1941 I started out but then in 1943 I went away to the war, you see. I was six years at the War, in the RAAF medical service. When I came back, I went off to Canberra for 14 years and then this estate was left to me and I started up again. Well, it's just times, the way things are — if you haven't got a full licence, you're out on a limb. You had to do what they wanted. So I stuck with the tankmaking.

I made that tank in 1949 for the abattoirs. I started at 8 o'clock in the morning and I finished it at 5 o'clock in the afternoon and I'm just going down the hut to have a cup of tea, and the chap called in and asked how much it was: 31 shillings. And after all those years gave me the tank back 12 months ago. You put loam in that side and sand in this side with a lid right over the top and it keeps for the garden, that's the idea of it. The taps are just decoration.

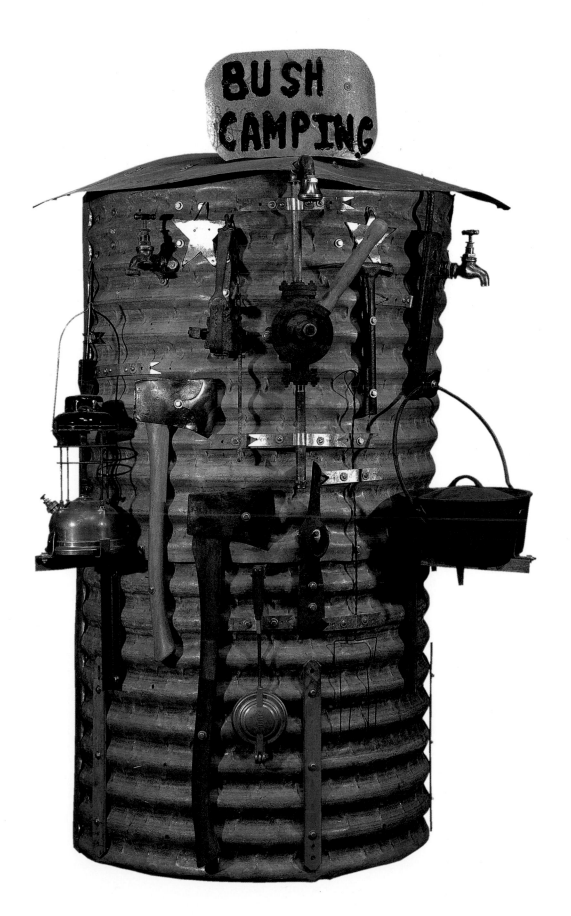

GEOFFREY RAYNER
Bush Camping, 1992
*Corrugated iron, old axes
and camping tools, 170 cm
Collection of the artist
Photograph: Robert Walker*

101

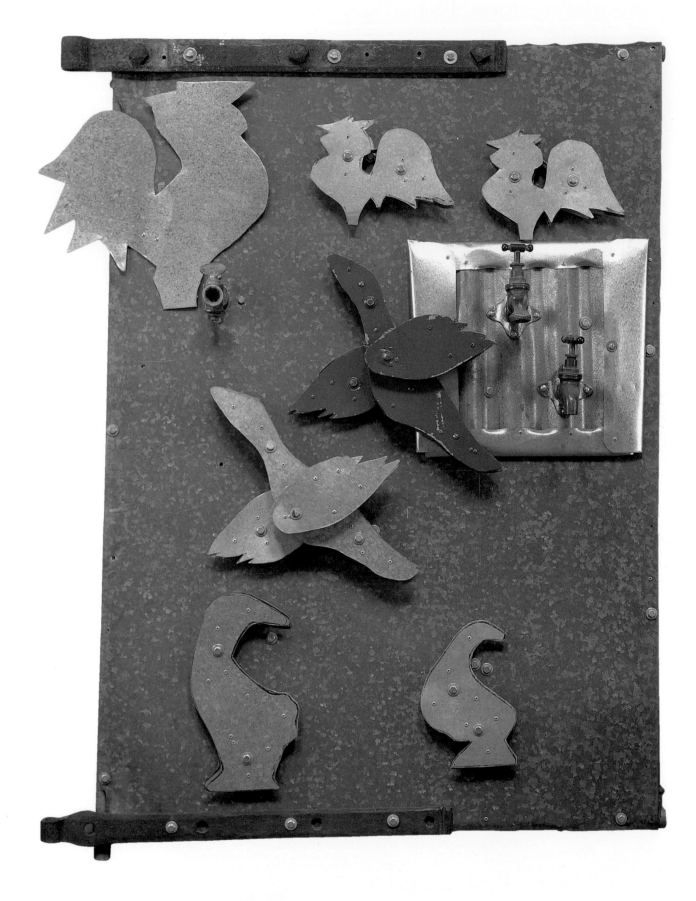

GEOFFREY RAYNER
Garden Tool Shed Door, 1993
Iron, tin cut-outs, 130 x 90 cm
Collection of the artist
Photograph: Robert Walker

I started doing all this in 1973 or 1974, but it's been all these years getting this far! One of these things that happen, isn't it? I get the inspiration and I'll do it — jeez, yes! Any time, anywhere. People say, 'What do you do with your time?' And I haven't got enough time to do everything!

That axe is an axehead cut with a mattock handle put into it: it's a blockbuster. It's cut millions and millions of tons of timber in its time. You get a Kelly axehead, swing it out, cut the tail of your mattock off, weld it in. That was in 1932 and welding was all done with gas. It was used as a blockbuster for cutting the logs up. They could have used wedges but I'll guarantee, no matter how tough the wood is, give me seven hits and I'll break it with a blockbuster. This timber was all in this district: yellowbox, whitebox and red.

I love the red and yellow timber. People don't know about it anymore. Look, out here at Bango Creek, you can go up and see the yellowbox trees, and it's magnificent! Oh, beautiful! And people say, 'What do you see in them?'! I love anything to do with nature — I go ecstatic. But people can't see it! You go out and see those gum trees with the ribbon hanging down, gorgeous yellowbox!

These tools all rigid wrenches. American. I earned my living from them when I was in Canberra. They done a lot of work. That was part of my history you see. They mean everything to me. They're part of my nostalgia.

That's the old spring-loaded tap. Over at the War Veterans' Home, the chaps used to put a bit of timber in there, between that and the basin, so the water'd keep running. As soon as you let it go, the water stops, see?

That's an English syrup tap. For molasses. That was a 1925 tap. That's an original Australian-made 1940 tap. That's a tank — Australian. Gee, there's beautiful iron in that though!

This effect on the corrugated iron? I'll tell you the secret. What happens it's only 26 gauge, very light — it's roofing iron. You put it in the electric rollers, and you turn them on, and all of a sudden you snap the power off. Looks good doesn't it?

This is the old tilly lamp, camp oven and pump, and the rabbit trap. That'll be elevated too. With timber inside. The tilly lamp is English: finest incandescent light

that was ever made! I bought spares of everything: the top piece, the globes. The globes are $18 each now. Beautiful light.

The old camp oven, that used to come out on the cradle of the chimney, and you'd hang that on it and put your camp oven and whatever you wanted on top, you see. That's to lift them with. It'd be red hot.

That's an English blacksmith's leg-vice. There's no more like it in this district! No way! I don't know the origin of it. It was given to me.

That plough made Tamer's Hill — on the Murrumbidgee for the bridge out there. In 1932 that ploughed most of that hill. Wouldn't that look nice in the Botanical Gardens up at Mount Annan? Ooh jeez it's got some character that plough! I don't know if there are any others around. There could be but I'd be very very surprised.

Here's the *Dunnies Galore*. They've all been sterilised. Oh gee yes I made sure of that! Well, you couldn't buy them off the Council 'til they were sterilised. Most of the toilets, they'd have a little door at the back, and he'd drag the pan out, pick it up like that and then over the shoulder it went. He had a longer handle. He was always drunk but you couldn't blame him could you?

I try and recycle materials that would normally be turfed out. Look at this: Reid, Yass. That's 1900! He was the first blacksmith in Yass. See that big bolt, the hinges are all handmade. But Reid was the first one. Another one over there was made by Barry, but this is the most prized one. They were on gates, and were going to be thrown out. Although Reid was in Yass he didn't put Y-A-double-S. He only put one 'S', because Barry had the franchise.

I go when the inspiration touches me and I'll be down at B & G Plumbing! I must go to B & G every day. Why, I don't know, but I've been so used to going down there. I get the inspiration might be a Saturday, Sunday, the early hours of the morning and I must come down. Or I develop it — put it down on paper.

I've never known anything about art. There must be something there in the background something in the family history. Must have been. But not that I know of.

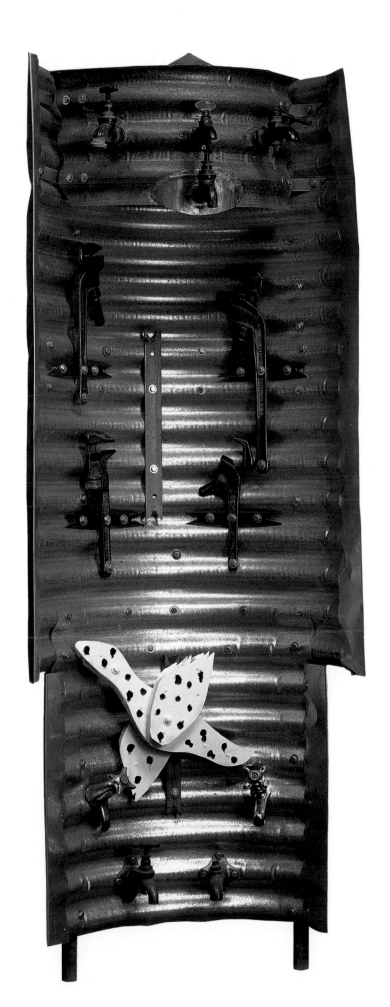

GEOFFREY RAYNER
The Rolls Royce of Plumbers' Tools (Rigid Wrenches), 1993
Corrugated iron, wrenches, taps
and tin cut-out, 180 cm
Collection of the artist
Photograph: Robert Walker

GEOFFREY RAYNER
Sunflower, 1992
Tin cut-out, 70 cm diameter
Collection of the artist
Photograph: Robert Walker

Janice Raynor

The attraction to clay? Probably because it wasn't easily accessible!
Not like paper or pens you could get from the local newsagents or you were given for Christmas. And the fact that it had to be fired. It has a magical quality. I still love opening a kiln: a glaze kiln is like Christmas! I still get excited. The day I don't get excited, I'll have to give up.

I've worked in other media, but I always came back to clay. There's something very satisfying about it. I think part of the magic is that the product that was a lump in a bag turns into something else.

Clay's a very masochistic form to work in because so many things can go wrong — from opening the bag to delivering it to the gallery. And after people have bought them you get notes: 'The workmen came in. It's in three thousand pieces, can you do something about it?' That's not unusual. Sometimes I can make additions and other pieces I completely remake if people want that, but there are other pieces that I really can't bear to make again.

There are certain things like Luna Park which I never grow tired of: I'd still like to make a Luna Park village where the pieces are big enough for children to walk around. The pieces would work on little mechanisms, so that, like the laughing clowns, you'd have little figures that would turn around. The scope is endless.

The very first piece I made was a Noah's Ark. I put the plastic on it to store it overnight, but I'd caught the kangaroo's arm, and so when I opened it in the morning, he had this limp wrist! Then I realised that there was only one of every animal in the ark, so it became the Singles Ark or the Gay Ark. There was a gorilla that was wearing a sloppy joe that said 'Noah'. It was just a silly piece. I really enjoyed it. I'd made it at home and took it to college to be fired. At college we were doing free-form abstractions and I had a couple of slabs left over which I felt lent themselves to a boat and that was really how it started.

The themes are eclectic — poetry, songs. Its actually the lyric line that interests me most — the poetry, the dense language and ambiguous imagery. It comes out in

the titles of my work. I either lift part of the line or twist it. Or it might be a book I've recently read, or a film. Ever since I saw *The Wings of Desire*, I've wanted to put wings on everything — pigs, cars, boats, bedknobs, anything. And that's very much a childhood fascination with little angels. And I suppose I'm recreating the childhood images that I loved and still love.

I went to church as a child but my favourite part was hanging about the graveyard before we had to go in because of the sculptures! Richmond is quite an historical graveyard. I hope they're looking after my angels!

I find it fascinating that every culture needs some kind of religion, some kind of dancing. Some people do it with angst: I certainly do use the clay in that manner. My show 'Postcards from Earth' was a response to current media focus on our planet. I felt that there was a need to have a retrospective look at the '50s and '60s when space the 'new frontier' was not just an adventure, it was an alternative to our own planet. At the same time I was working out a relationship: I mean another world, another planet and Love Remote Control. It fitted in so perfectly with what was going on in my life.

I was really playing on people who'd grown up on *Lost In Space*, *Star Trek* and *The Jetsons*: the rockets were really fat and colourful. The underlying joke was that it was an indulgence and the audience was there and it worked. It was quite a humorous show. People said it was good to laugh. I had really corny stuff like Doris, The Pearl, in her twinset. The little games you play! Doris Day was strong only when she was humiliating a man, as opposed to Emma Peel who was strong because she was strong herself. I'd always found Doris Day hard to deal with: it was a way of having a go at her plus the fact that the day before I made Doris, she'd made a Statement about AIDS victims and how they really should be disposed of! That gave me the invitation: Doris, I've always wanted to say something about you now's the time!

Other shows have been much more serious but when I make a political comment I have to be careful because I can sometimes back myself into a corner. I admire satire. But I don't always pull it off. When I make a political comment, if I make it too cutesy-pie, people who are attracted to it "Oh isn't that sweet!" are horrified when they find out the real meaning. Some people never do. Which I find amusing as well.

If you can make people laugh — but I need to laugh as well and that's why clay's a good friend. I use it when I'm in all kinds of moods. I don't say to myself, 'I'm in a

JANICE RAYNOR
Luna Lovers, 1992
Ceramic, 42 x 23 x 22 cm
Private collection
Photograph: Robert Walker

creative mood', but I can't say when my best pieces are coming either. That's why it's so attractive: at 3 o'clock in the morning, just as my eyeballs are falling out, something really funny will happen to the piece I'm working on. My pieces often change as I'm working on them which is great.

Naive? I can see it in the work. I've actually had people phrase 'naive' delicately because they don't want to offend me! Can I say I'm truly naive when I'm working in terms of references? When I'm working from things I've seen and read and bringing them together: the jokes, the verbal puns. It's not always obvious. The audience that laughs the most are those who know the references.

I feel more comfortable with it now because I feel that 'naive' is a category, it's a label. I've given myself a label: 'Ms Understood', which I feel comfortable with because it covers a large area. Naive art is such a wonderful experience — it's this growing creature. If naive is mask, puppets, children's art, icons, carnivals and storytelling then I would love to be associated with that aspect because it fascinates me to be able to capture the moment.

Hugh Schulz

I was born in Innisfail, Queensland in 1921. My mother died when I was 4 years of age and I was sent to the Guardians in Broken Hill where I did my schooling. At the age of 15 years I was working in Kalgoorlie Gold mines.

I mined and prospected on the Kalgoorlie goldfields until I joined the Army and served with the 2nd A.I.F. When I was discharged from the army in Sydney, I decided to look at Broken Hill again and stayed there where I prospected, then went on the Mines.

My daughters and their friends at High School got me illustrating their History and Geography books in coloured pencil, then watercolours which eventually started my art career.

I remember many amusing incidents and accidents from my mining career, but the comradeship was unequalled in the mines. Working in dangerous places made me appreciate the beauty of nature, particularly in semi-arid and arid regions.

Eric Minchin was short of paintings for a charitable art exhibition so he went around seeking the help of self-taught artists, mainly for originality and a great difference in art.

The exhibition was a success, so he suggested we stay together and work for charities. Until then, painting was a hobby for me when I could get the time. It's now about 14 years I've been painting full-time. The Brushmen of the Bush have raised over one million dollars for various charitable institutions.

HUGH SCHULZ
Broken Hill Landscape, *1983*
Acrylic on board, 50 x 70 cm
Collection: Alan Hill
Photograph: Robert Walker

Reny Mia Slay

I can't speak very authoritatively about my art; in fact, I felt quite paralysed at my exhibition in Sydney when introduced to prospective buyers. I don't think much about what I do. I spend half an hour doing sketches of some vague idea I might have thought of while I'm washing the dishes. If it's colourful and makes me laugh, I'll paint it.

Sometimes the bush neighbours come by and I drag them upstairs to my room for a critique. They make suggestions or wrinkle their noses or fall about themselves in admiration. I always know when people don't like naive painting. 'Oh,' they say doubtfully, 'How long did it take you to do that?' The implication being that it was a waste of time! And sometimes it is, but the lovely thing about acrylics is being able to wipe out mistakes and change colours on a whim. Which I do. Often! A whole seascape once turned into a restaurant in one painting, with only the foreground remaining from the original. It had spent almost two years of its life as a seascape, and was snapped up for sale as soon as it became a restaurant! What fun!

As a child I used to spend whole afternoons perched on a chair with my mother's art books. I liked the paintings of Chagall and Renoir, but it was Henri Rousseau's lush and mysterious jungle paintings that filled my head with exciting dreams. As I stared at those strange paintings choked with lush vegetation and exotic creatures, I imagined a peculiar world filled with adventure and intrigue.

Years later I did visit some jungles. I was entranced by the overwhelming profusion of trees, flowers, parrots and monkeys. Around the jungle towns of Central America I experienced the colour and spectacle that seemed to be a feature of the hot countries. Houses, boats and even lampposts are painted blue, purple, pink, red and green. Cemeteries are bristling with flowers, statues, small portraits of the dead, and colourful stucco shrines. Men strut about in loud shirts, eyeing-off pretty girls in their flowery dresses. Matrons sell fruits and vegetables heaped into colourful hills, yelling at passers-by to sample their juiciest mangoes and sweetest plums.

While all my paintings contain animals, most of them also feature women. Women are especially seductive and interesting in relation to exotic creatures. I like the offbeat, whimsical interaction between these luscious (some would say fat!) semi-

clad women and their attendant pussycats, elephants, bears, goannas, flamingoes and leopards. It doesn't matter whether they are in the jungle or in the living room; in fact, I rather like the idea of a monkey stealing fruit from the coffee table and a panther climbing the drawing room curtains.

Every painting tells a little story celebrating the odd link between human and animal. I try to recreate a slightly absurd and quirky relationship between the wild and the tame, the comfortably known and the imagined. A lion drapes itself over a tree limb, listening dreamily to a woman strumming the guitar. A flamingo stands next to a nude woman in an armchair, a large vase of chrysanthemums on its back. Two women pass each other in the desert night, one riding a zebra, the other a black panther. A nude dancer cavorts with a juggling cat upon a stage surrounded by jungle wallpaper. A panda holds a snake looped into a hoop for a circus performer to jump through, and zebras, giraffes, monkeys and lions stand around watching the show.

I live in the bush in northern New South Wales. I wish I could say that the lush forests and wondrous fauna are what inspires me in my painting. But although the serenity and beauty of the area is stimulating (and distracting), it is the childhood Rousseau dreams and my real and imaginary travels to lush, mysterious regions of the world that makes me paint the way I do.

RENY MIA SLAY
Curtain Call, 1991
Acrylic on canvas board,
28.5 x 21.5 cm
Private collection
Photograph: Robert Walker

Howard William Steer

You start painting because you want to start painting. I don't think one day you pick up a brush and say, 'I'm going to paint'. I think you just go out there and accidentally paint something. You doodle around. I'd always wanted to paint but never knowing how to paint, you virtually do your own thing and go from there. I just picked up a brush and had a go. Suddenly you've got oodles and oodles of paintings hanging around the house — against walls, packed in rooms and doorways.

After I won a few prizes in Sydney, I took some work to Joyce Condon's art gallery in Broken Hill. It's a small gallery — equivalent to some of those Paddngton galleries in Sydney. I asked her if it was sellable. She said she liked it. So I started taking the work out and selling it. I asked her questions about the paints she had on the shelves and what I needed to mix it with and she said, 'Oh, you'll need some linseed oil, you'll need this, you'll need that'. So I went home and by trial and error mixed the paint.

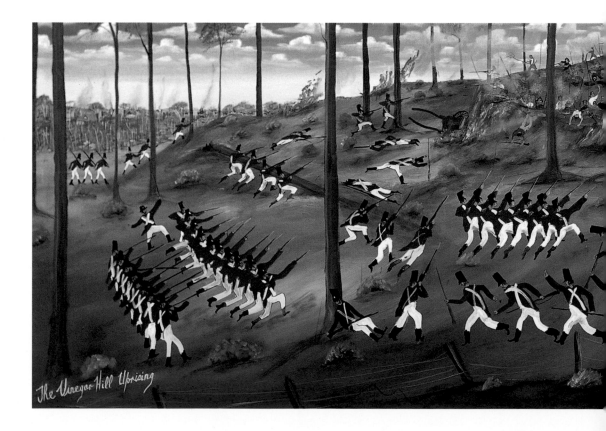

The Vinegar Hill Uprising

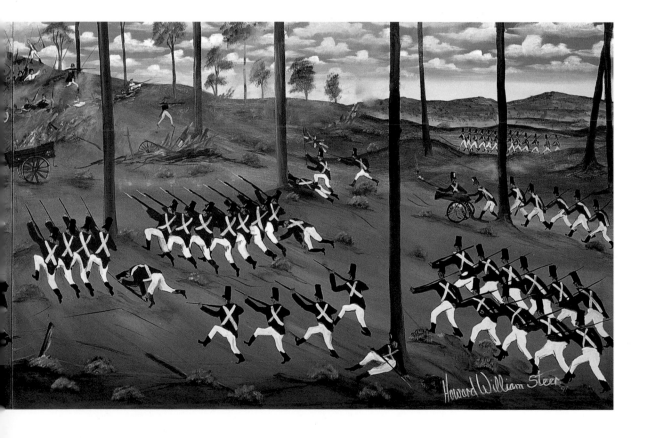

HOWARD WILLIAM STEER
The Battle for Vinegar Hill, 1804*, 1991*
Oil on canvas, 90 x 242 cm
Private collection
Photograph: Robert Walker

I do about 100 to 150 paintings a year and we've got no paintings at our house now. They all sell. There's so much history in The Hill that I think if I painted for another hundred years, I would'nt even paint half of it. The unions were a way of life in Broken Hill: there was the locking-out of the miners in 1909, the Spuds and Onions strikes, the scab miners.

A scab in the Union is a person who will go and 'scab' on their workmates by working for a lower price in the mines. The women would tar and feather the scabs and run them out of town. That was the violence of the place.

Scab graves would be built in the town. John Holbrook was one of the scabs in Broken Hill. He would go to work with protection from the police force. The coppers would protect him and take him to work for the Company. The miners were a very superstitious type of people — a lot of them are Cornish and they were very superstitious. To get back at him, they made a mock grave: 'Holbrook — Rest in Hell' and when they went past they'd spit on it and curse it.

There were a lot of pubs in Broken Hill in those days because miners would quench their thirst. Then more than quench their thirst. They'd get carried away with the time. Their wives, like my mum, used to put a meal on a hot china plate in a saucepan of water, with the lid of the suacepan on top of the plate, the steam keeping it hot. You could dry it out in an oven. The food waited for the husbands to come home from the pub. In the end, the wife would get fed up and chuck it out to the dog. That's where the expression comes from — 'Your dinner's in the dog'.

You can just imagine the wives in those days bringing up ten or twelve kids. The concept of the Pill wasn't about and there were big families. A lot of them were Catholic families. The guy was just a working-class man. A lot of it hasn't changed, but back in those days, it would have been a tough way of life.

People have already named the paintings. I use a lot of Australian slang sayings like, say, 'Your dinner's in the dog'. That's not one of mine. It's a saying that's been around since pussy was a cat. Or 'Stone the Crows! It's the Flying Doctor!'. That's virtually what the guy would have said. People can relate to it straight away. They laugh about it. So the paintings are entertaining as well as pieces of art. You've got to include yourself in one of those characters and imagine what you'd say back in those days.

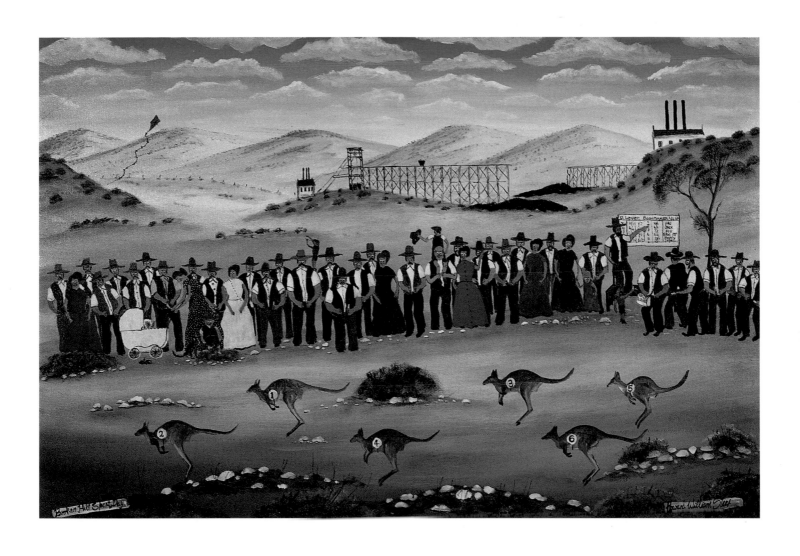

HOWARD WILLIAM STEER
Broken Hill Sports Day, n.d.
Oil on canvas, 60 x 90 cm
Collection: Lorna Lever
Photograph: Robert Walker

I try to put across the message that the underdog is the hero and at the end of the day, each cloud has a silver lining. It makes a person feel good, and if they feel good then they feel good about your art.

I get stories by talking to a lot of people. My great-grandfather was the Mayor of Broken Hill in 1912 and 1916 and his daughter's still alive. And Charlie Galloway. Charlie used to be a regular visitor, dropping in and telling me stories about when men were men and women were double-breasted. Some of the stories might be blown out a bit but there's a fair essence of truth in most of the paintings.

I envisaged *The Battle for Vinegar Hill* — with a bit of background research and looking at the view around the Castle Hill area in Sydney where the rebellion happened. No-one knows exactly what the whole thing looked like because there are no accurate pictures of it.

The pinnacle of the painting is the Hill in the middle. Your eyes rise to the top of the painting to find out what they are firing at. All the guns are facing up. There would have been a lot of fires — burning carts they put on the hillside to barricade themselves. The smoke from the fires would have provided camouflage. And they brought the canons in, so there's a lot going on all at once.

The rest of my paintings are series I've made up as I've gone. They're characters. The Flying Doctor's a character of my imagination.

There's a lot of artists that go out in the bush and paint the Flying Doctors and say well, that's the Flying Doctor. When you look, it's an aeroplane. It's not a Flying Doctor. You won't get that aeroplane to bring someone back to life after they've been kicked by a horse.

So I thought the best thing to do was to create a doctor. What would a doctor have looked like in the old days? Similar to the Western movies, I imagined a guy with a tall black hat. Naturally, he had a dark three-quarter length coat on and carried a black bag. So I put this doctor in the air with wings on him: naturally he'd got to be a flying doctor. Then I created this character of the Flying Doctor as a hero of the bush. He's the sort of bloke that gets up to no good sometimes and up to good in other times.

I've just done another big painting called *Patching up the Ozone Layer*. There's a bandaid in the sky over Sydney where all the pollution is and the Flying Doctor's flown down to repair the ozone layer. So he's not only in the bush, he's actually come to Sydney. I think you've got to address topical issues. You can't paint all history. I might be taking the micky out of it, but it gets the point across. It's a good talking point.

I think it's important in this day and age if people can laugh at a painting and enjoy it. They learn to live with the painting much better and it's a talking point: they tell their friends to look at this event or incident in the painting. They laugh about it — humour's a pretty important part.

It's good also when people don't like your paintings. If everyone liked all the paintings, I'd be painting bloody gum trees and bloody windmillls. Sidney Nolan didn't do it by painting gum trees and creeks. I hope one day I can be remembered as the guy that painted the Flying Doctor. Sid Nolan's the guy that painted bloody Ned Kelly. These are the recipes of life. If you follow them you can't miss. I honestly think you can't go wrong if you invent the character.

I wasn't frightened to put down what I thought about scab graves and the unions. They weren't pretty paintings — they were paintings which tell the story. I was the first to come up with the idea of story art. I want to be the best story artist in Australia, the best known story artist. Possibly, I'm the only one.

HOWARD WILLIAM STEER
Miner's Hat, 1988
Oil on hard hat
Collection: David Lever
Photograph: Robert Walker

HOWARD WILLIAM STEER
Stone the Crows, it's the Flying Doctor, 1992
Oil on canvas, 90 x 121 cm
Private collection
Photograph: Robert Walker

Phyll Stone

I'd painted all my life. My mother had been a painting teacher: she was supposed to be one of the best flower painters in Victoria when she was young. Her name was Lillian Roberts. She had a few students but she didn't teach us (the children). We painted with her out in the bush but she mainly painted flowers in the garden. My great-grandfather's cousin was Thomas Gainsborough.

I'd sketched all over the world on trips before I came back to Australia in about 1960 and started painting. I've always sketched on holidays.

My husband used to paint and I got sick of cleaning up after him every Sunday. I was so disgusted at all that beautiful oil paint going to waste. He used to throw it all out, every Sunday. So one Sunday I pulled this certificate of his down from the wall. It was his Membership of the Royal British Institute of Architects. I painted over the top of it. Two big beech trees with bluebells and daffodils underneath.

My son came home and hung it on its side. Shortly afterwards, a millionaire from Bondi came up to get my husband to design a house for him and he bought it off the wall. My husband said to me 'Did George do it?' (George is our son who's an architect and a town planner in Sydney) and I said, 'He must have!'. I didn't want to own up about painting on the certificate!

I kept painting after that picture. I don't know whether I am a naive painter or an impressionist. I used to think I was an impressionist. What do you think? I don't know.

I do paint funny little figures. I love to paint figures in a landscape. In fact I love to paint people, places and events more than anything. Or I might have a memory from my childhood. I have such lovely memories because as a child I used to visit my aunt who lived at Bendigo. I was always mischievous, so I was much in demand as a child to have to stay because I made them laugh so much.

After school, I went to Stotts in Melbourne and did a course in shorthand typing and bookkeeping. I worked in a solicitor's office first, then I went to the National Mutual in Melbourne. Walter Burley Griffin and his wife worked there. I used to go up in the lift

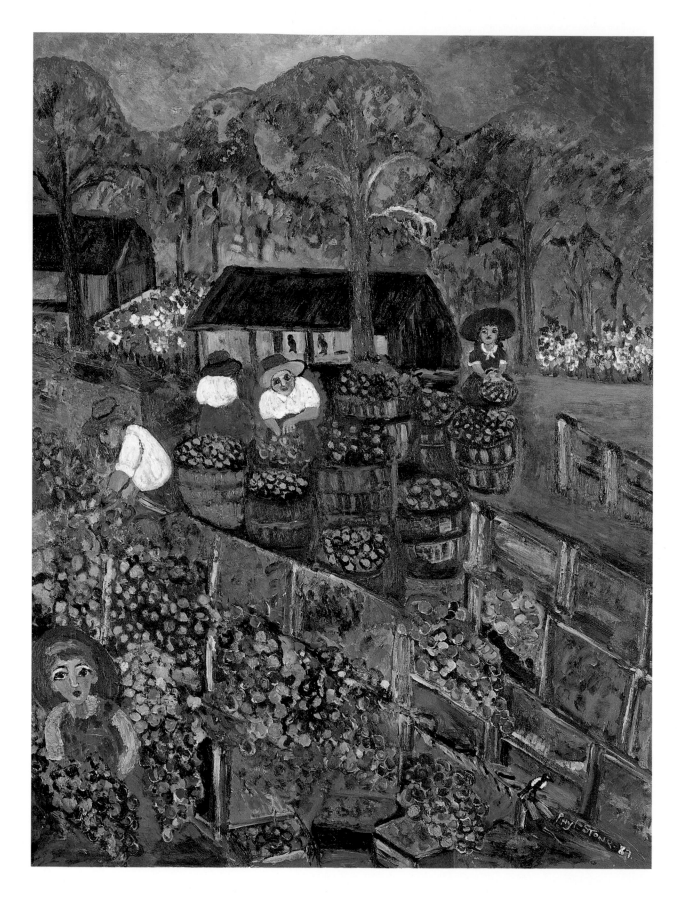

PHYLL STONE
The Grape Harvest, 1965
Oil and acrylic on canvas 120 x 90 cm
Private collection

with them every morning. She was a colourful character. She was the most interesting looking woman I'd ever seen. She was like leather, and she used to wear sandals without socks and in those days nobody wore sandals without socks!

Burley Griffin's wife taught me that a woman could work and be famous and cultured. In those days we didn't think women could attain much.

I met Dattilo Rubbo at East Sydney Tech. He was a perfectionist in tones. He'd lay out 30 tones of a colour: all ready. He went there to try and loosen up. I think it broke his heart when I got two paintings in the annual exhibition when he didn't and I was an absolute beginner!

Dobell was very interested in my paintings. He asked me if he could paint me the week he died.

I went to Joshua Smith's portrait class at the Von Bertouch Gallery in Newcastle for 10 days. He said I was like Picasso. I wasn't. He came to the first show at the Australian Naive Gallery. Afterwards, he wrote me a letter saying that they'd had a conference about me. He didn't like my paintings and he said both he and Evie wished they could paint like I did. To have the colour sense. He's very traditional. He uses one set of colours.

I've hardly ever seen a painter who's tidy. Dobell was untidy and I'm untidy. I can get into a mess in five minutes then paint on top of it all! But Dobell was like that you could hardly step through his home.

The Grape Harvest is a childhood memory from about 1915. We would pick the grapes, put them in buckets and take them to the big barrels and then to the winery at Crusoc Farm. That's me in the red hat!

Kristyn Taylor

I did a BSc in Zoology with Honours in Animal Behaviour. I never actually worked in animal behaviour — I went into protein chemistry.

When I met John, my husband, he'd started going to pottery classes. I thought 'How boring. Brown cups and mugs.' But then I actually had a fiddle with the clay and loved it. So I went with him on Tuesday nights for a couple of years. I was making bigger and bigger things and then I started selling them at the market.

The work has changed a lot: people who loved it in the beginning now hate it!

The very first stuff I made was quite cute: fat and cutesy. I used to go to the library and look at books on all sorts of art from different cultures, different periods of history — It was like all that stuff was swishing around in my head and it would come out. It wasn't going through my brain as such. I wasn't copying it, but it wasn't really me.

My experience of other people is beginning to filter through now. The *Dinner Party* is about my experience of other people. It's not just laying me out on the line.

The woman called *This is a War Zone, Baby* is the thirty-something who realises she's not getting any younger. So she's going to make the most of it. She's bought a Christian Dior lipstick in the hope that the more you pay, the better the result. She's actually my age and I've just bought my first Christian Dior lipstick. It's a stark reality — the dark roots growing out — she's got to get into the hair-dyeing syndrome.

And that's *The Boy*. He's well-hung; he's that essential ingredient at today's dinner party: the Extra Man. You usually find he's gay. He's out there pumping iron and driving fast cars. That big boofy kind of guy.

There's the *Self-Denying Vegetarian* who's protecting the chooks. Vegetarianism fascinates me. I like to have a dig at it.

The Gourmet. I come from a long line of know-alls. Especially the males in our family. Our dinner parties are terrible — everyone trying to outdo everyone else. The food

KRISTYN TAYLOR
Dinner Party, 1992
Ceramic, life-size
Private collection
Photograph: Philip Mandalidis

buffs. The wine buffs. The well-read know-all who twists the conversation to what they've read in the paper that day.

The Femme Fatale. I have this husband. He's older than I am and he's Irish and seems to be very attractive to women. It's really funny. So I've met a few femme fatales in my time.

That's *The Femme Fatale's Toy Boy*. She's the sort of woman who's got one man on the go but she's always on the lookout for another conquest. He's just a spare one.

The Pig. My father-in-law was a butcher in Ireland and my husband John is a really good cook. He cooks marinaded pork very well. We eat quite a bit of pork and it's almost like the revenge of the pork: *The Pig* looks like it would bite your arm off. It has crocodilian features.

The rooster in the cage is the *Coq au Vin*. The rest are ready to go through the mincer. *Coq au Vin* is actually more a focus on The Femme Fatale.

The Dinner Party just reflects part of the experience of being a woman. Getting older and coping with all that stuff.

My work has mixed reactions. I love that about it. It's funny watching peoples' different reactions as they come into an exhibition.

A lot of kids like my work. I teach at after-school centres, five to ten year olds. I love it: they're so inspirational. The way they're so fresh and the way they see things has really influenced my art.

John *Venerosa*

I just fell into it really. Up until about four years ago I'd done absolutely nothing, anything creative all of my life.

I've always had jobs where I could get away with doing as little as possible. Working on boats, working on the railways — jobs where I was working by myself and had lots of time to think or taxi driving 'cos I got to meet a lot of people. But mostly trying to do as little as possible in the way of work.

What happened was that I ended up with a family, so I thought well, I'll have to work! I fell into furniture restoring and it instilled in me a love of things with a history. Most of the stuff I worked on was stuff you'd call very rustic furniture, built by people who were farmers — the kind of people who didn't have much time to build furniture, so they got what was at hand and knocked it together. I learnt a lot of my building techniques off European peasant furniture and later Australian bush furniture especially Depression furniture. They built useful things out of what was at hand.

I was working with a lot of Spanish furniture, usually painted in very, very bright colours. It's hard to say how I got the whole thing with colour. It was what was there in front of me and I just did it.

My life's taking this turn now, and I'll follow this path which is what I've done all my life. I've just been blown by the wind basically. I can't say that I set out to do something, I just fall into things.

And the next thing I knew like about three or four years ago when this recession started and antique furniture died and I had no work, I realised that I'd been working with the stuff for so long that I could build furniture as well and I just started building things and painting them.

I met Etienne from the Naive Gallery; she encouraged me and I went on from that. I made something and she said it was fantastic and put it in her gallery and it sold. So I made something else and that sold, and something else and something else …

Usually I build the piece of furniture, then I just stare at it and usually something just pops into my head. Or I think about it beforehand and get a theme, like fish or flowers and it just sort of develops.

The first piece I ever did was a hall table with a painted top done very Aboriginal design with cut-out lizards racing round the edge in relief. I do lots of cut-outs and I have this thing about lizards, I like the way they just seem to be running around the movement in them. Its a very Aboriginal influence, the lizards.

I've spent a lot of time with Aboriginal people. The stuff I do is not very deep. It's mainly decorative and good fun. I don't claim to be an artist like a lot of Aboriginal painters are because there's a lot of depth to what they do and it goes back a long way. I just like the way they paint — dots. It's good fun. It's a nice way to paint. I just sit there going dab dab dab and pretty soon something starts to appear.

Most of my stuff's built from recycled materials. I usually find it on the street and every time I see a bin outside somebody's place they're doing renovations or something I stop and go through it. It's a very important part of my work, finding materials, not having to buy any materials, recycling what's around.

I was doing this television video cabinet, a commission, and I painted eyes all over it. That's when I discovered brass nails: I started sticking brass nails all over it and using bits of copper and stuff. I built it from scratch.

JOHN VENEROSA
The One That Got Away, 1992
Acrylic on scrap timber, copper,
145 X 85 cm
Private collection
Photograph: Robert Walker

JOHN VENEROSA
Stealing the Eggs, 1992
Acrylics and copper scrap
on meatsafe, 86 x 55 x 37 cm
Private collection
Photograph: Robert Walker

I don't plan beforehand what I'm going to do. The artwork on these is mostly spontaneous. I stare at it and it just comes out. Same with my carpentry except for the measurements. When I'm doing a commission that's basically a spontaneous thing, too. I have a pile of materials on the floor and it just happens. It's good fun. I like it. It's great. Makes me very happy.

I work down at Blackwattle Bay on the water. I open the doors, stare out at the water, watch all the little tug boats. You can see the Harbour Bridge. It's a very nice place to work. The whole building's full of eccentric people. A lot of industry goes on around here and they throw away lots of stuff I can use. I'm always on the lookout! So its a good place to be.

Susan Wanji Wanji

I started painting at school at Maningrida. We used bright colours. I painted turtles and fish and my father's canoe. That was my favourite. My dad made me a canoe, small — not really small, middle-sized. I took them old people and kids across the Liverpool River to the other side for cockles and oysters and yams. I also learnt weaving at school. We got old people to teach us weaving, get pandanus and dye colour. After I left school I did health work and weaving. I moved to Crocker Island and worked in the health centre in the mornings, in the afternoon I used to sit with them old people under the tamarind tree, them mob doing carving and bark painting.

When I was a kid I used to go with my father, I used to sit on the back (of the canoe) and my cousin and grandfather would stand up the front for killing turtle. I had a little paddle that my dad made. Sometimes my father used to get live one so I could ride on the back. My father used to tie it to a tree, I used to tell it to 'keep going, keep going'. Big ones. They had lovely colours on their back, I used to like that colour. I always have liked that colour. We went fishing too. My father used to dive in the water and use the spear gun to kill the fish. He used to dive in the water and wait for that fish to come, and spear him.

My dad used to go a lot to Elcho Island and Millingimbi for important ceremonies — men's business. He used to travel a lot. I only know those two language a little bit, I can understand but not talk them. I used to go back and forth to Maningrida and Goulburn Island.

My people dance turtle. Two people they paint themself on the back, they cover with blanket so them mob can't see them then they come out and crawl on the sand, like copy turtle. That man crawl behind, that woman first. He scratch her on the leg and try to wish her.

Only my brothers they dance fish, tuna fish. They paint fish on their front, put tail on their legs. Women didn't dance, only they take dilly bag and gammon get the fish (dancers) in the bag. All the women calling out 'big mob fish here' but really men. The men sing song about turtle.

Sometimes they dance eagle and he come down and take the fish away. That's all the dreaming. They paint up to look like different fish. Some have skinny fish dreaming, some have mullet, some have tuna. Us mob have tuna.

I started working at the Munupi Art Centre (Pularumpi) in 1990. I was doing canvas painting and then after started doing gouache painting, then linocut, etching, lithograph and screenprint. I like doing linocut and painting especially.

In June I went to Paris for exhibition. We went for a look around at them other paintings, really big ones, really different, lots about Jesus and his mother. We went where they chop that queen head off, made me feel little bit sad. We went for a ride on a boat up the river — a lot of houses, too many houses. Paris was a good place but a lot of people we don't understand. Home is better.

Max Watters

After watching my brother Frank (now Director of Watters Gallery, Sydney) painting with his artist friends in the late 1950s at Muswellbrook, I decided at about the age of 24 years to try painting myself. I began by painting the usual subjects: figures and still lifes.

Getting nowhere with this work, I decided I would try landscape painting. Believing that you had to go out in the country and do the painting on the spot, I set out. For some unknown reason I tried a creek scene. It was a disaster and I gave away trying to paint landscape for about a year.

While walking around our backyard one day I saw over our back fence the old railway gatekeeper's building. I did a coloured sketch of it then, taking my time, I proceeded to paint it in oils on hardboard. The title of the first work was *The House at No. 5.* 'No. 5' refers to the gates that the keeper looked after. From that day on, all my paintings are derived from a coloured sketch I have done of the subject. It is then enlarged to the size I believe is appropriate.

On winning the local art prize in 1964 and thinking my work lacked the technique of oil painting, I asked the judge at that time what I should do. The judge, Mr Daniel Thomas, gave me the best advice I have ever had. He said, 'You have five paintings in this exhibition. You know your subject — just paint'.

That is what I've done ever since. I work on various paintings at the same time — up to about 18, in two different sizes: medium and large. The largest is 4 ft by 3 ft. I use pure colour, straight from the tube.

I have always regarded my paintings as enjoyment and as a hobby. Having a secure job with Pacific Power at the Liddell Power Station has enabled me to continue painting, regardless if my work sells or not.

A building or buildings are depicted in my work. I firmly believe that the building retains the character of the people who built it or who live in it.

If you achieve what you set out to do, or surpass what you were capable of doing, that's great. If people like what you have created or you win an award, then that is the icing on the cake. The rewards of creativity can far exceed the financial side. I should know I've been there and done it. It is a great feeling.

MAX WATTERS
House and Sheds, Gundy Road, 1992
Oil on hardboard, 82 x 112 cm
Private collection
Photograph: Robert Walker

Elizabeth Wood

I was married in 1964 at the age of nineteen years and came to live in the Golden Valley, not far from Brisbane. The next seven years were preoccupied with pregnancy and child raising: my five children were born during this period. Although I found time to write poetry and several short stories, it was not until my children had all started school that I was able to give freer expression to my pent-up creative energy.

One morning I woke, drew back the curtains to the fresh new day and, as light streamed into the room, my mind was illuminated by a perception that I could best describe as 'The Dance of Life'. Outlined by the starkness of the window frame, the bright vision of the world impressed me with incredible intensity and I felt overjoyed in the understanding that what I was observing was 'The Great Work of Art' and that I was part of it.

So that I could share this revelation with other people, I proceeded to erect frames of all sizes in the paddocks around the farm. Some were very large and framed views that stretched to infinity, while others were quite small and highlighted things that might otherwise be unnoticed.

I staged the 'Dance of Life' exhibition at the Easter Festival of Arts to the music of Beethoven's *Pastoral Symphony* and Bach's *St Matthew Passion*. Visitors were invited to participate by stepping into the frames to be viewed and at the same time to view the scenes from all angles. One frame swaying gently from the bough of an ancient Moreton Bay fig tree was entitled *Portrait of a Young Girl* and was modelled by my eldest daughter, Jacqueline. The last frame showed the view stretching away to the horizon with the great vault of the bright blue sky showing us glimpses of infinity and eternity. My statement for this exhibition was 'The Dance of Life is the Art that is Me'.

After this I began painting the events of our lives in the beautiful arcadian setting of Closeburn. I also drew on the experiences of my early life and when I returned to Mount Carmel at Redland Bay, I painted my personal 'dreamtime' in the series 'Genesis to Revelation'.

ELIZABETH WOOD
High Tea, 1989
Oil on marine ply, 120 x 120 cm
Private collection
Photograph: Prolab, Brisbane

High Tea is from the series 'Over in the Old Golden Land'. Our farm at Closeburn is situated between the Golden Valley and the magnificent western backdrops of the D'Agulan Range. From Mt Glorious springs Cedar Creek, and into it flows Love Creek. Joined, the creek flows down through our farm on its way to the sea. In summer we spend many happy hours with family and friends swimming and enjoying the beauty of the creek.

In the 1970s when our old dairy buildings were first used by the Closeburn Artists Community, on Sundays refreshments took the form of a tea ceremony, artists and friends participating. Scones were baked in the old wood stove and served piping hot with jam and cream and large pots of tea outside in the fresh country air.

High Tea was completed just as the word 'perestroika' first came to our ears. I would like to think that all people will one day be free to express themselves without political repression. On the spout of the teapot I painted small gold infinity symbols, to indicate the ongoingness of life, and the irrepressible *joie de vivre* of the human spirit.

William Yaxley

I came to paint as an outlet for my daydreaming. I was fascinated by exotic places and adventures but I'm also cautious, so most of my adventures are in my mind, where I can't get into trouble.

Before I do a picture or a statue, I have developed the image in my mind, then I do a small sketch on some scrap paper. I then use the sketch as my guide.

At this stage of my life, I'm a little more confident about my art but still feel a bit guilty that I'm avoiding 'real' work.

As regards the description of my work being 'naive': well, maybe the experts will come up with a better word one day. It's better for me just to do the stuff and leave analysis to others.

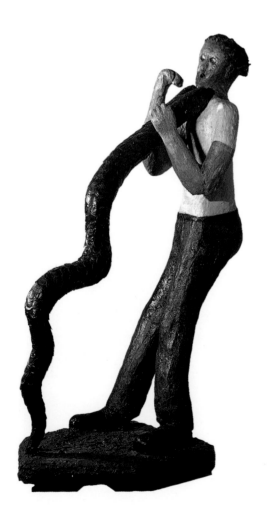

WILLIAM YAXLEY
Quiet Walk in the Bush I, *1990*
Mixed media, 116 x 85 x 60 cm
Collection: Ray Hughes Gallery
Photograph: Robert Walker

Goodbye Paradise is a painting of our previous farm at Byfield, on the Central Queensland coast. The realisation that life was short and our time at Byfield was finished was expressed by depicting us as battered-looking butterflies flying away.

Quiet Walk in the Bush I and II came about after a friend, Peter James, came to visit us at our new home in Tasmania. We went for a short walk in the adjacent bush where we found on the pathway, a large, evil-looking tiger snake. A few metres further on, we encountered an equally evil-looking copperhead. I imagined the worst scenarios: being bitten in the groin, and a large snake sinking its fangs into the side of my throat.

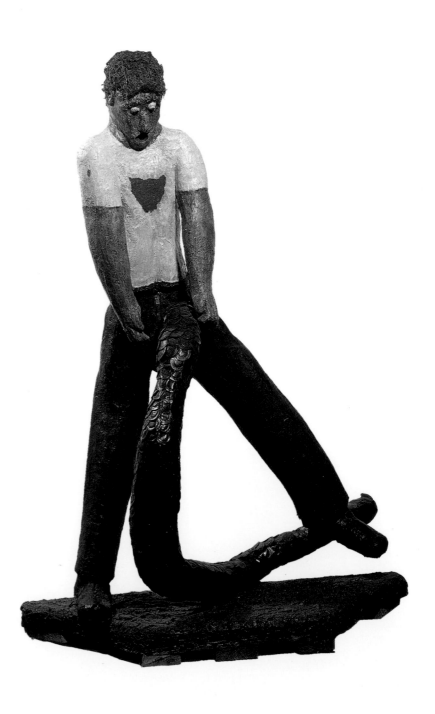

WILLIAM YAXLEY
Quiet Walk in the Bush II, 1990/1
Mixed media, 115 x 70 x 40 cm
Collection: Ray Hughes Gallery
Photograph: Robert Walker

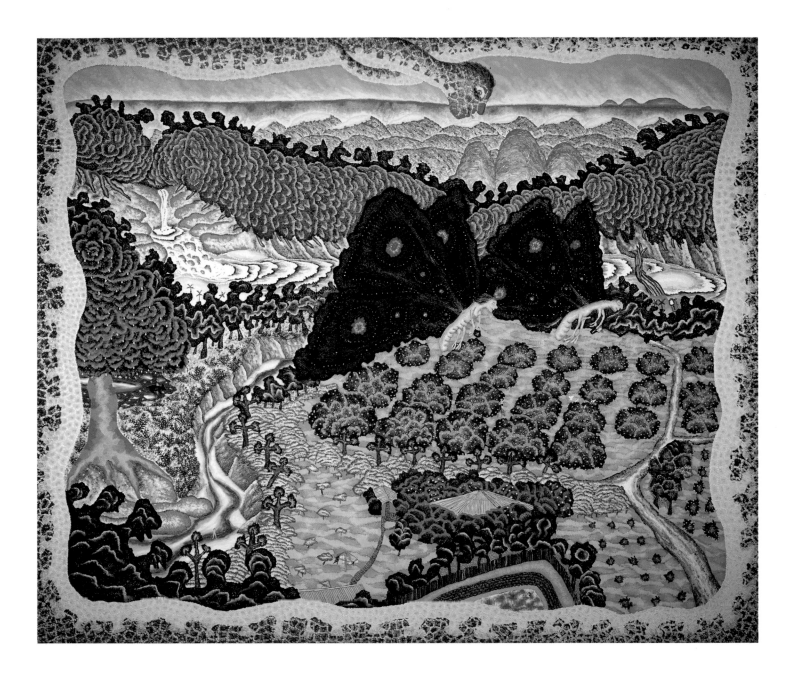

WILLIAM YAXLEY
Goodbye Paradise, 1990
Oil on canvas, 150 x 180 cm
Collection: Peter and Joyce James
Photograph: Courtesy University of
Queensland

Biographies

IAN ABDULLA

Born 1947 Swan Reach (Murray River) South Australia. One of 12 children, Ian spent most of his infancy with various white foster parents as was the practice in those days. After rejoining his family, Ian lived with them in and around the Riverland area. When he was old enough, Ian worked on farms and for Community Welfare in Adelaide and Coober Pedy. He now lives in Barmera, a small town in the Riverland, with his three children. Ian began exhibiting in 1989 at Tandanya Aboriginal Cultural Institute in Adelaide. Since then he has taken part in many shows, including 'Tbyerrwerryiou' (I'll never grow to be a white man) at the Museum of Contemporary Art, Sydney (1992), ARCO Contemporary Art Fair, Madrid (1993), and 'Images of a First Language', Prospect Gallery, Adelaide (1993). Represented in Sydney by Hogarth Galleries. His first book *As I Grew Older*, the life and times of a Nunga growing up along the River Murray, was released by Omnibus Books in February 1993.

Photograph of the artist by Pip Blackwood, Courtesy of *Adelaide Advertiser*, 6 February 1993

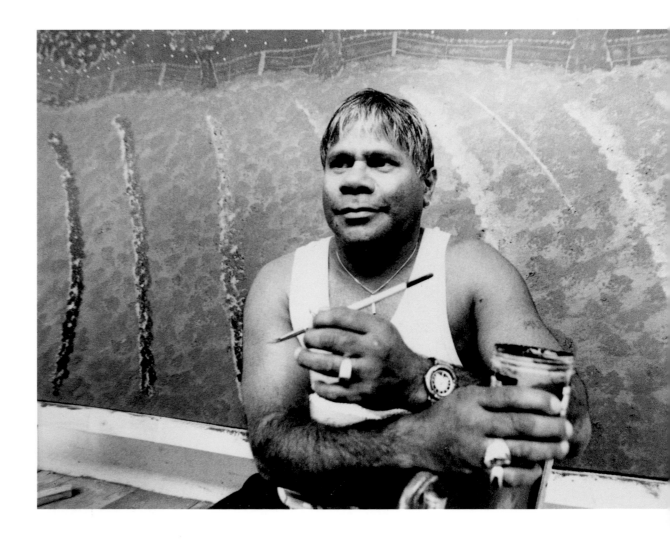

JOHN CAMPBELL

Born 1951, grew up in Sydney. Holds a BA in archaeology and ancient history. Travelled extensively in the Middle East, Europe and India. Ran a clothing business in Sydney with his wife before they moved to the far north coast of New South Wales where John began to paint in 1988. Since then his work has been included in over 14 exhibitions in Sydney, Brisbane and the Byron Bay area.

Photograph of the artist by Loretta Egan

GWEN CLARKE

Born 1938 Orbost, Victoria. Worked in Melbourne as a nurse for 12 years. Began painting in 1965, showing her work in local group exhibitions over the next 20 years. Between 1986 and 1991 several solo exhibitions at the Gallery Art Naive, Melbourne and the Australian Naive Galleries, Sydney. In 1991 her paintings were shown in group exhibitions of Australian Naive Art at Queensland House, London and at the Musee d'Art Naif in Paris. Lives Bairnsdale, Victoria.

SISTER CLARE CONNELLY

Born 1930 Toowoomba, Queensland. Worked as a nun, teaching in rural Queensland. Now lives at All Hallows Convent, Brisbane. Represented by Baguette Gallery and Riverhouse Galleries, Brisbane. The National Gallery of Australia acquired two of her etchings in 1990.

Sister Clare Connelly in her studio at 'All Hallows'.
Photograph of the artist by Martin Jorgensen

STEPHEN CONVEY

Born 1950 Melbourne. First exhibited at Kelly Street Kollectiv Gallery, Melbourne in 1987 and since then, many exhibitions of Outsider Art in Sydney, Melbourne, New South Wales regional galleries and overseas at the Galerie Cannibal Pierce, Paris, Iwalewa Haus University, Bayreuth, the Bockley Gallery, Minneapolis and Gallery Bordeaux, France. Lives in Melbourne with his wife and children.

SYLVIA CONVEY

Born 1948 Germany. Exhibited extensively since 1976 principally in Melbourne, Sydney and Canberra. Exhibitions overseas at Galerie Cannibal Pierce, Paris, Bockley Gallery, Minneapolis and Iwalewa Haus University, Bayreuth. Her work has been acquired by the National Gallery of Australia, the Collection of Art Brut, Lausanne and the Outsider Archive, London among others as well as many private collections in Australia and overseas. Lives in Canberra with husband Tony.

TONY CONVEY

Born 1946 Victoria. Exhibited
extensively since 1981 at major
contemporary galleries
throughout Australia and
overseas at Galerie Cannibal
Pierce, Paris, Bockley Gallery,
Minneapolis and Iwalewa Haus
University, Bayreuth. Examples
of his work are held by the
National Gallery of Australia, the
Australian Collection of Outsider
Art, Sydney, the Australian
Gallery of Sport, Melbourne,
Artbank, the Collection of Art
Brut, Lausanne and the Outsider
Archive, London, and other
public and private collections in
Australia, the U.S. and Europe.
Lives in Canberra with wife Sylvia.

PHYL DELVES

Born 1923 Nabiac, New South
Wales. Since the 1960s has been
entering her work in local art
prizes in and around the various
country towns in which she
has spent her married life —
Muswellbrook, Wagga Wagga,
Maitland and Newcastle. Lives in
Merewether, New South Wales
with her husband Douglas.

EDITH DUNSTAN

Born 1916 Gladesville, Sydney. One of 11 children, the Depression forced Edith to leave Fort St Girls High School early in order to work. In 1946 married and lived in Brisbane until 1952 when she returned to Sydney with her son and supported them both working as a secretary/ bookkeeper. On her retirement from full time work in 1975 she completed an Adult Education Fine Art course and began an art course at East Sydney Technical College. During 1977–81 Edith completed a BA at the University of Sydney and began to enter her paintings in exhibitions at Macquarie University. In 1989 Edith was included in an Australia Council funded project involving interviews with artists. This led to an invitation from Gary Anderson to participate in a group exhibition at his gallery, 'A Private Collection' (1989) and a solo show in 1991. Now lives in Hunters Hill, Sydney.

IRIS FRAME

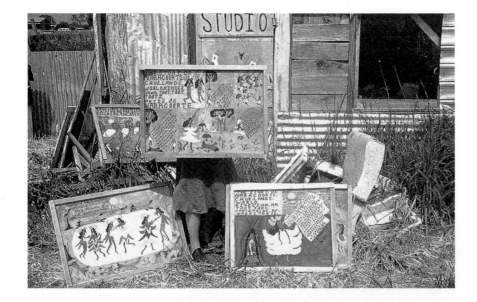

Born 1915 Renmark, South Australia. Family early pioneers in the Mt Gambier district. Shortly after her marriage in 1943, her husband became ill and Iris ran the house and the farm, went out to work as well as looking after her husband. When he died, Iris moved with her mother to Tarpeena where she began to paint in earnest. In 1975 she set up The Lands of Fantasy Fantastic Art Gallery at her home where prominent contemporary artist Vivienne Binns discovered her. After the property was sold, Iris moved to Penola where she still lives and paints today. Her work has been acquired by Riddoch Art Gallery, Mt Gambier and the Art Gallery of South Australia.

ANNIE FRANKLIN

Born 1962 Coffs Harbour, New South Wales. Diploma of Applied Art (Printmaking) Charles Sturt University, Wagga Wagga, New South Wales. She has been exhibiting professionally since 1987, including solo shows at Canberra Contemporary Art Space (1988), Shades of Ochre, Darwin (1989, 1990, 1991), Punch Gallery, Balmain (1990) and Australian Girls Own Gallery, Canberra (1990). Worked as a graphic artist 1982–1990. Since 1990 Art Advisor at Munupi Arts & Craft, Pularumpi, Melville Island. Her work is represented in the National Gallery of Australia, Wagga Wagga City Gallery and the Megalo Screenprint Collection, Canberra.

ANNE GIBSON

Born 1959 Sydney, Exhibited Left Bank Gallery, Sydney (1987, 1989), Punch Gallery, Sydney (19910, 1991), Dubbo Regional Art Gallery (1990), Bondi Pavilion, Sydney (1990), Waverley Art Prize Exhibition (1991). Performance Slides, Harold Park Hotel and Belvoir Street Theatre, Sydney. Wrote and illustrated *Forders The Dog* (Hodder & Stoughton 1990). Lives in Sydney.

Photograph of the artist by Anne Zahalka

MARIE JONSSON-HARRISON

Born 1958 Stockholm, Sweden.
Grandparents circus artists.
Father a sculptor who brought
the family to Australia in 1972.
She ran away from home the
following year and by 1975 had
embarked on a highly successful
modelling career. She retired in
order to have children and
concentrate on her art. Exhibited
since 1989 at Gallery Art Naive,
Melbourne, Contemporary Art
Centre, Adelaide, Elders Fine Art
Gallery, Adelaide, Loreto
College, Adelaide, Australian
Naive Gallery, Sydney,
Greenaway Gallery, Adelaide
and Gallery Harvest, Nagoya,
Japan.

Photograph of the artist:
Courtesy *The Producer*

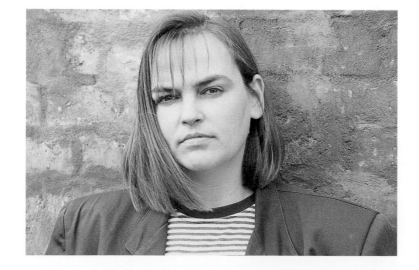

ELFRUN LACH

Born 1955 Ratingen, Germany.
Studied art history, Egyptology
and archaeology at Cologne
University. Arrived Australia
1982. Solo and group shows at
Gallery Art Naive, Melbourne
(1982–1989), Manuka Gallery,
Canberra (1985), The Elgin
Gallery, Melbourne (1991),
Australian Naive Galleries,
Sydney (1992). Exhibited
overseas at Queensland House,
London (1989), Musee d'Art Naif,
Paris (1990). Lives in Melbourne.

KEVIN LANE

Born Bega, New South Wales 1949. As a monk worked in Papua New Guinea and later as an English teacher in various countries around the world. Exhibited PNG (1972), Turkey (1976), Greece (1978), Sweden (1983–85), Barry Stern Galleries, Sydney (1985, 1986, 1987, 1991), Naughton Studio of Naive Art, Sydney (1988, 1989), Australian Naive Galleries, Sydney (1990, 1991, 1992), Gallery Art Naive, Melbourne (1990). Lives Gothenburg, Sweden.

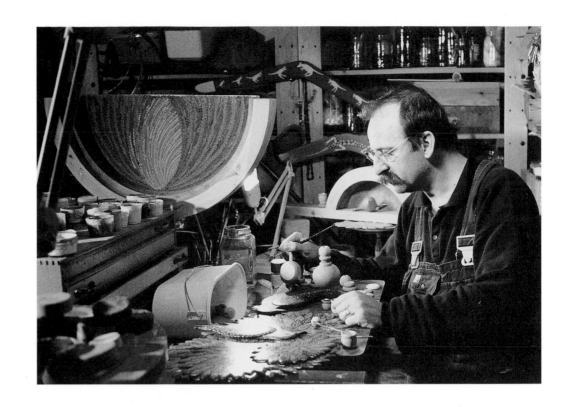

FRANÉ LESSAC

Born New York. Studied film at University of California. Spent five years on Monserrat in the Caribbean where she began to paint. Went to London where she finished work on her first book, *My Little Island* (1984). She has published a further 12 books since then. After some time in Paris, Lessac went to Bali to film a documentary on Balinese painters and met her Australian husband. They now live in Fremantle, Western Australia.

BOB MARCHANT

Born 1938 Dimboola, Victoria. Encouraged to paint at high school by teacher Ella Service. When his parents won some money, Bob was able to go to art school in Melbourne where, as he was uncomfortable with the current fashion for the abstract, he concentrated on graphic art. After winning £500 in the first *Sun Herald* Art Competition, he left for England and spent 20 years working as an advertising art director. Returned with his family in 1980 to settle in Sydney. Within 10 years he had won the Sulman Prize twice (1988, 1989) — the first artist in 45 years to win the prestigious award in two consecutive years. Solo exhibitions The Moore Park Gallery, Sydney (1988, 1989, 1990), Greenhill Gallery, Perth (1991, 1992), Merril Chase Galleries, Honolulu (1991), Holdsworth Gallery, Sydney (1991), Australian Naive Gallery, Sydney (1992), Mulgara Gallery, Sheraton Hotel, Ayers Rock (Artist in Residence, 1992), Moross Studio Gallery, Los Angeles (1992, 1993). Lives Bundeena, New South Wales.

Photograph of the artist by Billy Wrencher

DENIS MEAGHER

Born 1951 Sydney. Worked in the Public Service for 10 years. Retired in order to improve his quality of life. Casual work restoring old furniture led to painting furniture and his first exhibition at Australian Naive Galleries, Sydney (1992). Lives in Sydney.

LOTJE MEYER

Born 1954 The Netherlands. At the age of 12 began several years of private tuition from Dutch painter Jan Brugge. Studied at The Academy of Arts Minerva, Groningen (1973–87) before moving to Amsterdam where she worked for two years as Art Director in a large advertising agency. Arrived Australia 1981 and freelanced in art direction and illustration. Exhibited Naughton Studio of Naive Art (1989), Australian Naive Galleries, Sydney (1990, 1992). Lotje lives in Sydney and now devotes her time solely to her painting.

MIRIAM NAUGHTON

Born 1925 Sydney. 1942–45 Australian Army, stationed in North Queensland. 1945–50 Assistant to Superintendant of Yarraba Aboriginal Mission, North Queensland. 1950 married and moved to Gooligal Grazing Station in western New South Wales where she produced the first of her six children. 1956 moved to Port Moresby, Papua New Guinea. 1962 moved to Sydney. Exhibited Blake Prize, Blaxland Gallery, Sydney (1966, 1967, 1970), Sulman Prize, Art Gallery of New South Wales (1969). Recommenced painting in 1982 after a 12 year lapse. 1986 Barry Stern Galleries, Sydney, Rainsford Gallery, Sydney, Gallery Art Naive, Melbourne, Blake Prize, Blaxland Gallery, Sydney. 1987 Naughton Studio of Naive Art, Sydney, Sydney Theatre Company, Winner — Waverley Art Prize, Sydney. 1988 Sulman Art Prize, Studio of Naive Art, Sydney, Sydney Theatre Company, Winner — Waverley Art Prize, Sydney. 1988 Sulman Art Prize, Art Gallery of New South Wales, Naughton Studio of Naive Art, Sydney. 1989 *Up from Down Under* exhibition at Queensland House, London, Musee d'Art Naif, Paris. Lives in Sydney.

Photograph of the artist by Marc Vignes, Courtesy *The Cairns Post*

MALCOLM OTTON

Born 1917 Devon, UK. Arrived Australia 1940. Worked a mixed farm on the Central Coast of New South Wales until 1946 when he joined the Commonwealth Film Unit. Trained as a director and made documentary and educational films. Between 1977–1982 produced series of films on Australian portrait painters (*Painting People*), sculptors (*Sculpture Australia*) and initiated and produced a series of 32 films on Australian painters from Von Guerard to Whiteley (*The Australian Eye*). Began painting in 1982. Exhibited: Australian Naive Galleries, Sydney (1990, 1991); Musée d'Art Naif, Paris (1990); RONA Gallery, London (1992). Lives in Sydney.

MAITREYI RAY

Born 1954 Calcutta, India, where she spent her childhood. Came to Australia in 1964 with her family. Graduated with a degree in Fine Arts from Melbourne University in 1974. Exhibited: Eltham Centre, Melbourne (1988, 1989); Gallery Heritage, Melbourne (1990); Australian Naive Galleries, Sydney (1991, 1992); BMG Gallery, Adelaide (1991); Greenaway Gallery, Adelaide (1992): ARCO Madrid (1993). Lives Panton Hills, Victoria.

GEOFFREY RAYNER

Born 1925 Yass, New South Wales. Worked as a plumber in Yass until 1943 when he joined the Royal Australian Air Force. Stationed in Darwin and the Philippines. Returned in 1949 and worked as a plumber in Canberra and Yass. Began to make objects 1973–74. Now fully retired. Never exhibited. Museum of Contemporary Art, Brisbane, acquired 3 pieces of his work in 1992. Lives in Yass, NSW.

JANICE RAYNOR

Born Richmond, New South
Wales. BA Dip Ed (University of
Sydney). Fine Art Certificate, Post
Certificate Ceramics (National
Art School, Sydney). Exhibited:
Blake Prize Selection, Blaxland
Gallery, Sydney (1986, 1987,
1988); Naughton Studio of Naive
Art, Sydney (1988, 1989); Ray
Hughes Gallery, Sydney (1989,
1990); Sylvester Studios, Sydney
(1989); EMR Gallery, Sydney
(1990); Australian Naive Galleries,
Sydney (1990, 1991, 1992); Punch
Gallery, Sydney (1990, 1991);
Mura Clay Gallery, Sydney (1991,
1993). Represented in
Queensland Art Gallery
collection. Lives in Sydney.

HUGH SCHULZ

Born 1921 Innisfail, Queensland. Went to school in Broken Hill. Began working underground in the Kalgoorlie Mines at the age of 15. Served in World War II as an infantry engineer. Upon discharge, returned to Broken Hill where he continued mining until his retirement. Schulz exhibited with the Brushmen of the Bush 1973-1989 in galleries all over Australia and in the USA, Europe and the UK. Exhibitions at Broken Hill City Gallery (1990, 1992).

Photograph of the artist by David Mahony

RENY MIA SLAY

Born Canary Islands. Father a market gardener, mother a naive artist. After graduating from university in California, she wrote a book on homesteading and hitchhiked to Bolivia. Worked in Mexico as tour guide and co-ordinator at a centre for ecology before moving to Hawaii. In 1982 she was in Tasmania as Expedition Leader to a well known Australian author. For the next seven years she travelled the world, taught courses in landscape design, edited two books on permaculture and planted several thousand trees. Began painting in 1990. Exhibited Australian Naive Galleries, Sydney (1992). Lives in the bush in northern New South Wales.

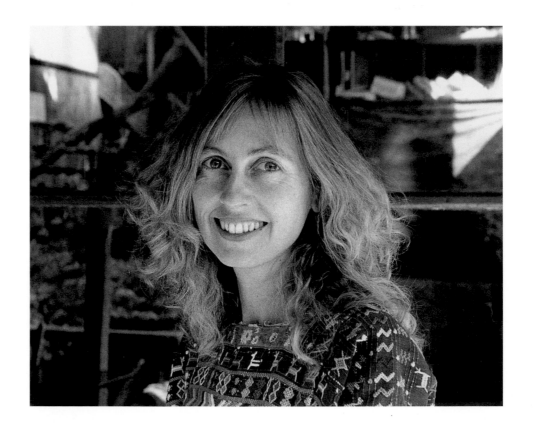

HOWARD WILLIAM STEER

Born 1947 Broken Hill, New South
Wales. Began painting in 1970.
Exhibited: Anthill Gallery and JC
Art Gallery, Broken Hill (1985);
Gallery Art Naive, Melbourne
(1987, 1988, 1991); Naughton
Studio of Naive Art, Sydney (1987,
1988); Madison Galleries, Los
Angeles (1988); Libby Edwards
Galleries, Melbourne (1988);
Broken Hill City Gallery (1988,
1990, 1992); Australian Naive
Galleries, Sydney (1990, 1992);
Musée d'Art Naif, Paris (1990);
Kookaburra Gallery, Portsmouth,
New Hampshire, USA (1990);

Noosa Regional Gallery (1991);
Jan Taylor Gallery, Sydney (1991);
Dubbo Regional Art Gallery
(1991); Capricorn Art Gallery,
Melbourne (1992); Barry Stern
Galleries, Sydney (1992).
Represented in collections
of Swan Hill, Dubbo, Lake
Macquarie and Broken Hill
regional galleries and Coca
Cola, Melbourne. Lives in Broken
Hill.

Photograph of the artist by David
Mahony

PHYLL STONE

Born 1905 Rushworth, Victoria. Exhibited widely since 1965 including Newcastle City Gallery (1965, 1969); Von Bertouch Galleries, Newcastle (1966); Gallery A, Melbourne and Sydney (1967); Powell Street Gallery, Melbourne (1968, 1971); Orange City Gallery (1978); Art of Man Gallery, Sydney (1978); Seekers Gallery, Sydney (1980); Cook's Hill Gallery, Newcastle (1981); Woolloomooloo Gallery, Sydney (1987, 1990); Australian Naive Galleries (1990). Represented in collections including National Gallery of Australia, Newcastle Region Art Gallery, Floating Art Gallery of Sweden and Newcastle University. Lives in Newcastle.

Photograph of the artist with her portrait of Dr Robert Steiner, Rheumatologist

KRISTYN TAYLOR

Born 1959 Wellington, New Zealand. Arrived Australia 1977. University studies in zoology and psychology 1977-88. Ceramic classes at Willoughby Art Workshop 1983-86. From 1987 full-time ceramic artist. Exhibited: Centre Art Space, Sydney (1987); Glen Galleries, Noosa (1988, 1989); ICCG shows, Sydney (1988, 1989); Painters Gallery, Sydney (1988); Beaver Galleries, Canberra (1988); Sydney Aquarium (1989); Australian Naive Galleries (1990, 1991, 1992 solo); Gallery Art Naive, Melbourne (1990); Taronga Zoo, Sydney (1991); Mura Clay Gallery, Sydney (1990 solo, 1991); Gold Coast City Art Gallery (1991); Punch Gallery, Balmain (1992); Manly Art Gallery and Museum, Sydney (1991). Lives in Sydney.

Photograph of the artist by Philip Mandalidis

JOHN VENEROSA

Born 1951 Melbourne. Worked at various jobs on boats and the railway and driving taxis. In 1988 he got a casual job restoring and painting old furniture for a Sydney dealer. Having learnt some technique, he began to make his own pieces and soon after was showing them in the Australian Naive Galleries. Lives in Sydney.

SUSAN WANJI WANJI

Born 1955 Maningrida, Central Arnhem Land, Northern Territory. Father's country — Flying Fox Creek, Arnhem Land. Mother's country — Navy Landing, Liverpool River, Arnhem Land. Clan — Miyartinga (Pandanus Tree). Dreaming — Mantupunga (Tuna Fish). Spent time working on Goulburn Island, Croker Island and Melville Island. Exhibited: 'Shades of Ochre', Darwin (1990); National Gallery of Australia (1991); Australian Naive Galleries, Sydney (1991); Gallery Gabrielle Pizzi, Melbourne (1991); Studio One, Canberra (1991); Hogarth Galleries, Sydney (1991); Savode Gallery, Brisbane (1991). Lives at Pularumpi, Melville Island, Northern Territory.

MAX WATTERS

Born 1936 Muswellbrook, New South Wales. First exhibited in 1964 in Naive Painters of Australia, Gallery A, Sydney and Melbourne and in 1965 with Henri Bastin and Muriel Luders at Watters Gallery, Sydney. Solo shows: Watters Gallery (1966–); Newcastle Region Art Gallery (1971 retrospective); Powell Street Gallery, Melbourne (1972); Maitland Art Gallery (1978, 1982 retrospectives); Muswellbrook Art Gallery (1978 retrospective, 1987); Cook's Hill Galleries, Newcastle (1978, 1983); Stuart Gerstman Galleries, Melbourne (1981); Broken Hill City Art Gallery (1982 retrospective); Victor Mace Fine Art Gallery, Brisbane (1984); Murulla Gallery, Muswellbrook (1989, 1992). Represented in National Gallery of Australia; Art Gallery of New South Wales; National Gallery of Victoria; Newcastle Region Art Gallery; Artbank; Wollongong City Gallery and many other regional, institutional and corporate collections. OAM for Services to Art (1992). Lives in Muswellbrook, NSW.

Photograph of the artist by Jason Mell

161

ELIZABETH WOOD

Born 1944 Redland Bay, Queensland. Grew up on Mt Carmel Orchard in a deeply religious, pioneer farming family. Helped establish a creative arts co-operative at Closeburn and continues to co-ordinate visual and performing arts projects in the local area. Exhibitions: Naughton Studio of Naive Art, Sydney (1987); Redland Art Festival Centre Gallery, Surfers Paradise (1988); Savode Gallery, Brisbane (1989, 1990, 1991); Baguette Gallery, Brisbane (1992); Evonne Mills Gallery, Mt Glorious (1992); Strathpine Council Chambers (1992). Lives at Closeburn, Queensland.

WILLIAM YAXLEY

Born 1943 Melbourne, Victoria. Started painting at school and continued on his working trips around Australia carrying out surveys for a mining company. Went overseas where he travelled extensively and worked at many different jobs — clerk, labourer, driller, factory hand, meat worker, scrub cutter and fruit picker. Returned to Australia and settled in Queensland on an orchard. Occasionally exhibited his paintings at regional galleries.

Began exhibiting with Ray Hughes Gallery in 1981. Gradually the work started selling and when the money coming from this source was greater than the income from the fruit, Yaxley sold up and moved to Tasmania to paint and sculpt full-time. Lives at Dunalley in southern Tasmania.

Photograph of Yaxley working on sculpture at Griffith University, Brisbane 1989.

Further Reading

Bihalji-Merin, Oto *World Encyclopedia of Naive Art*
Bracken Books, London 1984
ISBN 0-584-95062-4

Borlase, Nancy 'Naive, and proud of it'
The Bulletin, 30 November 1974, pp.48–62

Britten, Stephanie (ed) *Artlink* Naive Art issue,
Vol 12 No 4 Summer 1992–93
ISSN 0727-1239

Cardinal, Roger *Primitive Painters*
Thames & Hudson, 1978
ISBN 0-500-53024-6

James, Peter 'Naive Art' (extract from *Visions of Paradise*)
monograph-in-progress — William Yaxley.
Ray Hughes Gallery Newsletter, No. 8 September 1988

Larkin, David (ed) *Innocent Art*
Pan Books, London 1974
ISBN 0-330-24217-2

Lehmann, Geoffrey *Australian Primitive Painters*
Queensland Press 1977
ISBN 0-7022-1039-0

McCullogh, Bianca *Australian Naive Painters*
Hill of Content Publishing Co, Melbourne 1977
ISBN 0-85572-081-6

Raw Vision. International Magazine of Intuitive & Visionary Art
Distributed in Australia by Manic Exposeur
ISSN 0955-1182

Melly, George *A Tribe of One. Great Naive Painters of the British Isles*
Oxford Illustrated Press, 1981
ISBN 0-902280-80-5

Moore, Ross *Sam Byrne. Folk Painter of the Silver City*
Viking Penguin Books, 1985
ISBN 0-14-0064218

Olsen, John 'Naive Painters', *ART and Australia*
May 1964, pp.10–17
ISSN 004-301X